ANCIENT STONE CROSSES
OF ENGLAND

Also published by Garnstone Press

MYSTERIOUS BRITAIN
Janet and Colin Bord

THE OLD STRAIGHT TRACK
Alfred Watkins

THE VIEW OVER ATLANTIS
John Michell

CITY OF REVELATION
John Michell

TIMELESS EARTH
Peter Kolosimo

THE GREEN ROADS OF ENGLAND
R. Hippisley Cox

THE BLACK HORSEMEN:
ENGLISH INNS AND KING ARTHUR
S. G. Wildman

ANCIENT STONE CROSSES
OF ENGLAND

ALFRED RIMMER

WITH 72 WOODCUTS

GARNSTONE PRESS

ANCIENT STONE CROSSES OF ENGLAND
was first published in 1875 by Virtue & Co., London,
and republished in 1973 by
GARNSTONE PRESS
59 Brompton Road, London SW3 1DS
ISBN: 0 85511 420 7 ✓
Introduction and Index © Garnstone Press, 1973

Printed in Great Britain by Lewis Reprints Ltd.
London and Tonbridge

A NOTE FROM THE PUBLISHER

This idiosyncratic and delightful record of many of the ancient stone crosses of England is one of the most complete records of their sites and appearances ever to be published. It appeared first in 1875—before the requirements of motor car travel began to infringe upon urban and rural centres alike—and it does we think deserve a place on the contemporary antiquaries' book shelf. To this reprint we have added a thorough Index which will we hope further aid researchers, local and early English historians to locate the former sites and—if they are lucky—the continued existence of the crosses which Alfred Rimmer, to use his own expression, notices here. There is much to discover and understand about the nature of locations of "ancient monuments", as they are sometimes called; it is often forgotten, for instance, that our earliest "crosses" are in fact Christianised standing stones which seem to have had a distinct role in prehistoric travel and/or ritual. *Mysterious Britain* and *The Old Straight Track*, both published by this company, discuss their possible roles in some detail.

M. D. B.
GARNSTONE PRESS
1973

CONTENTS.

————

CONTENTS.

b

XII.

LIST OF ILLUSTRATIONS.

——•——

ANCIENT STONE CROSSES OF ENGLAND.

I.

 TRUE picture of England as it existed in the fourteenth and fifteenth centuries would now be regarded as the dream of an antiquary or an enthusiast. Abbeys, churches, and crosses bristled over the land, and though for three centuries cruel war has been waged against them, there yet remain sufficient noble examples of English architecture to indicate what a wealth of grandeur and beauty has been swept away. Mr. Ruskin says even of the present day, that "the feudal and monastic buildings of Europe, and still more the streets of her ancient cities, are vanishing like dreams; and it is difficult to imagine the mingled envy and contempt with which future generations will look back to us, who still possessed such things, yet made no effort to preserve, and scarcely any to delineate them."

As an instance of the treasure of design that has been lost, we may mention that, of those most beautiful crosses, the Queen Eleanor memorials, only three are left—one at Geddington, one at Northampton, and one at Waltham,

twelve having been destroyed; and these three have
furnished the design for nearly all modern memorial
crosses. Some very good ones have doubtless been built
after the model of Waltham, such as the Martyrs' me-
morial at Oxford, Ilam drinking-fountain, and Bishop
Fulford's monument, in Montreal Cathedral Close; and it
is no disrespect to the architects to say that their success
has been exactly in proportion to the fidelity with which
they have adhered to their originals.

The varieties of design in the few crosses that are left
to us is surprising, and will form the subject of future
consideration. If native English talent had been en-
couraged, and if in place of modern tombs we had adhered
to ancient English types, our cemeteries and graveyards
might have been solemn, peaceful places, wherein we
could have walked without being shocked with evidences
of bad taste. Nothing is more impressive than a re-
cumbent knight, or lady, lying on a tomb, with their
hands folded as in prayer, as we may see in almost any
old parish church in England; and the tall, graceful
crosses that were swept away by the Puritans are just
such monuments as would make a graveyard beautiful.
Statues and sensational classic groups succeeded re-
cumbent effigies, and disfigured England during the reigns
of the Georges at enormous cost; while graceful crosses
were superseded by unsightly and unmeaning obelisks.
The vast number of monuments in Westminster Abbey
that were erected during the reigns of the Georges are
notorious for bad taste. Heroes and statesmen, with a
fair accompaniment of heathen deities, would seem to be
holding high revel in the venerable building. There is

a small cemetery at Overton, overlooking a beautiful bend

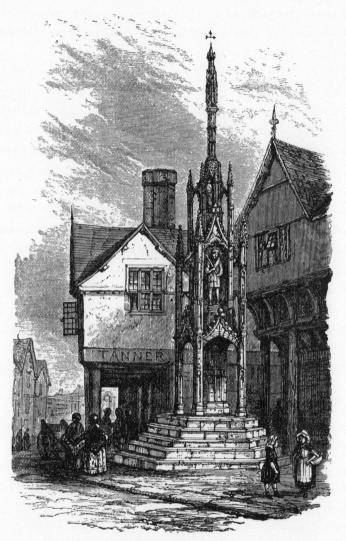

Winchester "Butter" Cross.

ot the river Dee, which is in excellent taste. The pro-
prietor, it is believed, exercises a censorship over the

tombstones; and though these are plain and simple
crosses, the effect is good. Indeed, one only regrets the
more that the genius of those who designed the Eleanor
crosses has so completely perished out of the land.

The ancient crosses of England have been divided into
Memorial, Market, Boundary, Preaching, and Weeping
Crosses. The market-cross of Winchester, engraved on
the previous page, is a structure of great grace and beauty.
It is called the "Butter Cross;" some kind of distinctive
name is often applied to local market-crosses; thus that
at Salisbury is called the "Poultry Cross." Milner con-
siders it to have been erected in the reign of Henry VI.,
but it probably dates back as far as Edward III. Britton,
writing of it only some forty years ago, says it was suffer-
ing much from the "wantonly careless practices of boys
and childish men;" it is hardly credible that even in
his time so meek a plea was urged for the preservation
of national monuments. "This, as well as all other
practices of public folly and mischievousness, should be
decidedly discountenanced," he says; "for when curious
memorials of antiquity are once destroyed they cannot be
replaced, and almost every person, sincerely or affectedly,
regrets their annihilation." This cross is about forty-five
feet in height, and is now well preserved.

But Winchester is only an example of a much more
capacious style of cross; it afforded accommodation for
but a very few persons, and that imperfectly: the really
valuable and useful covered crosses are those which, in a
much larger area, could shelter a crowd of market-people
from the wet, as the crosses of Malmesbury, or Salisbury,
or Chichester do at the present day. True it is they are

only a partial shelter, and singularly inadequate to the
requirements of an ordinary market-town; but circum-
stances have now much changed; fewer persons used to
attend, and round the market-cross booths were erected

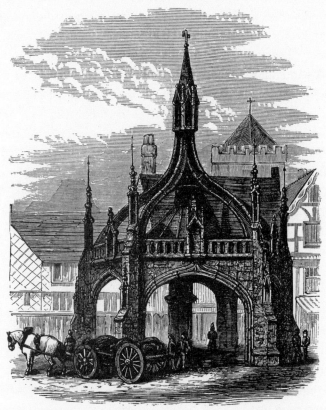

Salisbury Market-Cross.

when necessary. These temporary shelters were always
to be had in a town,—much more readily, indeed, than we
could get them now,—and the proprietors let them, as
stalls at Leadenhall are rented.

Nothing can exceed the picturesque beauty of Salisbury Cross. The stone it is built of is a warm grey. It stands in a nook in the market-place. The sun lights it up fairly and well, and on a busy day it contrasts quaintly with the groups of market-carts and country people. It belongs to the few canopied crosses that are left us, and differs from Chichester and Malmesbury in many important particulars. These market-canopies were at one time built of oak—in counties where that timber was cheap. They may have been taken down and used for porches, or embedded in more recent buildings. It is certain that four were standing early in this century; and it would be matter of sincere congratulation if one of these cherished relics of the past could be added to the Art-treasures of the nation; indeed, it is not too much to hope that even some of the stone crosses may be unearthed as Chester has been; and a very few fragments would suffice, if not to restore, at least to suggest to modern architects some new combinations and forms.

Chester market-cross was demolished at the general destruction of crosses, when the Cromwellites, following the example of the destroyers of monastic buildings, warred against these objects of beauty. The remains were buried near St. Peter's Church, in Chester, and about seventy years ago conveyed to Netherlegh House, where they were made into a sort of rockery in the grounds, and, before the present proprietor came into possession, they suffered even more mutilation; enough, however remains of them to guide us to a probable restoration, with the assistance of a rude drawing made by Randal Holmes and preserved in the Harl. MS. The street scene

is as Chester is at present, though, of course, it differs

Chester " High-Cross," restored from old fragments at Netherlegh.

from the appearance of the city when the cross was
standing. There was happily a limit to the rage for

destruction that prevailed during the period we have alluded to, and looking at some of the obvious relics left, we are led to fancy that even the soldiers of Cromwell experienced something like satiety in breaking down excellent carved work with " axes and hammers." The stone of which Chester Cross was built is very perishable, quite as much so as the Cathedral, and when Randal Holmes made his drawing it was more than two hundred years old. Under the shelter of this cross, the annual riot took place when the mayor left office. An account of one of these riots is preserved by Randal Holmes, and reflects much credit on the mayors for the conscientious way in which they prosecuted the duties of their office. In 1619, we are told that the energies of the mayor flickered up, as it were, with his expiring dignities, and seeing a tumult, he " could not forbeare, but he went in and smote freely among them, and broke his white staff, and his crier Thomas Knowsley broke his mace, and the brawl ended." The name of the dignitary, on reference to a list of the Chester mayors, seems to have been Sir R. Mainwaring. There were other crosses, however, in and around Chester at the time, which are occasionally alluded to in the earlier records of the city.

Market-crosses originated in towns where there were monastic establishments, and the " order " sent a monk or friar on market-days to preach to the assembled farming people. Probably the theme dwelt on was that they should be true and just in all their dealings, and the effect was doubtless beneficial. Milner, in his " History of Winchester," says, " The general intent of market-crosses was to excite public homage to the religion of

Christ crucified, and to inspire men with a sense of mo-
rality and piety amidst the ordinary transactions of life."
These relics also gave the religious house a central point
to collect the tolls paid by farmers and dealers in country
produce for the privilege of selling in the limits of the
town; and until very lately this same tax was held by
certain families in England, who exacted a toll from each
head of cattle that was brought into the market-town
for sale; indeed, it probably exists in some few remote
country places at the present time. The original form of
market-crosses, according to that most patient and careful
investigator, Britton, was simply a stem like Chester—a
tall shaft on steps; but in order to shelter the divine who,
with his collector, officiated on market-days, a covering
was added, and this seems to have been literally the way
in which Cheddar Cross, in Somerset, was built. These
small covered crosses were, no doubt, the origin of covered
markets. There are several ancient market-places almost
of a transitional kind, like the one at Shrewsbury, which
was built in 1596, and affords space for a hundred people
with their produce.

The cross at Corwen, which is there called Glendower's
Cross, is clearly of a much earlier date than the chieftain
it is named after; there is a curious dagger cut in relief
on one face which hitherto has not been accounted for.
It probably terminated in a sort of Greek cross like the
one at St. Columb, illustrated on page 11. This form
is common, and abounds in Cornwall and Ireland. It
has been supposed to represent wicker-work, but the
intersecting circle, which is finely shown in the low cross
at St. Columb, was not improbably a conventional attempt

to signify a halo. The halos round the heads of saints in pictures, even, were very solid-looking designs. One or two more crosses of this description will be alluded to hereafter, where there is a slight variety; but as a general rule there is much sameness, and consequently only a modified interest in them.

Glendower's Cross, Merioneth.

Crosses were introduced originally, it would seem, in the southern and western parts of the island, and travelled slowly, and by no means uniformly, to the north. Mr. Blight has illustrated the antiquities of Cornwall in a very careful manner; he is of opinion that crosses are more common in the west of this country in consequence of the earliest preachers having come from Ireland ; while in the

northern parts, which were visited by Welsh missionaries, they are scarce; at any rate, the similarity between the Cornish and Irish crosses is very striking.

The earliest preachers of Christianity do not seem to have made violent attacks upon the creeds and beliefs of their converts. Their preaching more resembled that of St. Paul at Mars Hill: they pointed to the groves and

St. Columb Cross, Cornwall.

holy wells, and dedicated them in another name. Cross-roads also were held peculiarly sacred in the early times, and even as far back as the period of the Druids they were marked by upright stones, not dissimilar to those we see at Stonehenge, though, of course, much smaller, and these stones were chiselled on the upper part with a cross in relief.

When these crosses are near a well, as at St. Keyne,

they are often picturesque objects; but this is owing, generally, more to the surroundings than to any merit in design. The number of them near ancient wells is very great. We are led by a consideration of the Cornish crosses to speak of those at Sandbach, which are among the most perfect and the oldest examples in England. They are situated in the eastern part of Cheshire, and were probably erected at an early period of the Saxon rule. They were demolished with much persistency during the last century, great violence being necessary to destroy them; but fortunately the remains, which had been dispersed and used to ornament grottoes and doorways, were collected in 1816, and, at the suggestion of George Ormerod, re-arranged in accordance with their former condition.

In taking a rapid glance in this introductory chapter, we see that market-crosses resembled the "preaching-crosses" before alluded to. There are still some beautiful remains of the latter, which seem to have been designed for the preacher to address congregations in summer weather in the open air. St. Paul's Cross, which was destroyed by order of Cromwell, was the most celebrated preaching-cross in Europe; it was also often used for political purposes. There are remains of these crosses at Iron-Acton and Disley, in Gloucestershire, and several in Hereford; formerly they were abundant, but they commonly shared the fate of St. Paul's Cross.

Boundary crosses were very important in marking the limits of parishes and manors. There are many remains of these round Chester. At Stalbridge, in Dorsetshire, there is a good cross, thirty feet high, on three flights

of steps, with niched figures of the Virgin, St. John, &c.

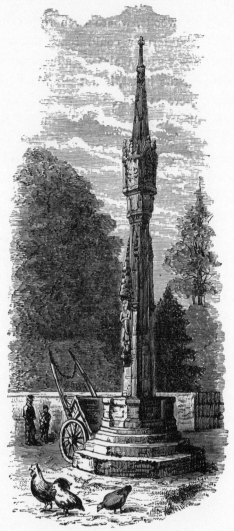

Stalbridge Cross, Dorset.

Sometimes crosses performed the important office of
being sanctuaries. Near Delamere forest, in the middle

of Cheshire, are several ancient crosses that tradition asserts were for the convenience of travellers passing through the dense woods, where even robbers respected them, provided the former could reach the cross first. Memorial crosses have been already alluded to; there are in England two of the finest, if not the very finest, in the world. Weeping-crosses were erected for the use of those who were compelled to do penance by the parish clergyman. There is an example of one of these in Flintshire, not far from Holywell. It is known by a Welsh name which signifies the Cross of Mourning, and was formerly supposed to mark the site of some lost battle or other event.

We see, then, from the time when crosses were introduced by the earliest preachers of Christianity into England, or from the time when Justinian ordered them to be placed in all Christian churches, to the time when they were deliberately demolished by Act of Parliament, they were applied to many purposes, and branched out into endless forms and devices. There is hardly any limit to the variety and beauty of the crosses which adorn the gables of churches. They mark each period with precision, and so great was their number that the remains which have been spared are numerous.

II.

HERE were probably not fewer than five thou-
sand crosses in England, of the kinds already
indicated, at the time of the Reformation; and
though they may admit of some such classifica-
tion as that mentioned, they must have been erected for
many other objects and on many other occasions than
have been enumerated. Some crosses, for example, were
supposed to have peculiar claims on certain classes; like
one at King's Weston, in Gloucestershire, most beautifully
situated on the Severn, at which sailors paid their devo-
tions after a voyage. This cross was celebrated far and
wide; a judicious hole was cut in the stone to receive
the contributions of those who had profited by it, or hoped
to do so. I am indebted to Canon Lysons, of Gloucester,
for furnishing me with the following extracts, which show
how universal, even at an early period, the use of the cross
was:—"Tertullian (*De Corona Militis*), writing A.D. 199, or
one hundred and twenty years before the conversion of
Constantine, to which period most writers have been in the
habit of tracing the use of the cross, writes:—'At every
commencement of business, whenever we go in or come
out of any place, when we dress for a journey, when we go
into a bath, when we go to meat, when lights are brought

in, when we lie down or sit down, and whatever business we have, we make on our foreheads the sign of the cross.' And Chrysostom, in 350, says : 'In the private house, in the public market-place, in the desert, on the highway, on mountains, in forests, on hills, on the sea, in ships, on islands,'" &c. This last quotation is extremely suggestive of the great variety of places where crosses are found. In a future chapter we shall dwell more particularly on the versatility of design that has been expended on them, and our own inferiority in ingenuity and resource to the mediæval architects. Nothing illustrates this more for- cibly than the obvious incompetence of the profession to deal with new materials, for example, plate-glass, where no precedent has been furnished—what would an architect of the fifteenth century not have given for such a splendid material ! But now whenever it is introduced in large plates, in a Gothic building, the effect is simply a kind of Alhambra appearance—not the old Alhambra, the modern one. The drawing here given illustrates a very simple object indeed,—the converting a square base into the base of an octagon shaft. These square bases are the top steps of different crosses ; and by splays or brooches they become, in the next stage, octagonal shafts, having a very satisfactory and finished look.

To take another familiar instance. We have for more than a century been content with the modern square marble chimney-piece over a fire-grate, with a flat slab for ornaments, which is an institution peculiarly of the eighteenth and nineteenth centuries. I do not know that anything so dreary has ever been devised for any purpose whatever ; nor would it be easy to invent anything else

so bad, and yet these are being put up by hundreds daily
throughout the length and breadth of the land. Perhaps
a worthy rival might be found in the sash-windows which
have supplanted casements. The latter when open or
closed, as the case might be, broke to some extent the

Bases in Gloucestershire and Norfolk.

monotony of a weary row of square windows, such as we
see in a London street; and in a happy moment some
one invented a sash-window, to give a finishing touch to
the baldest kind of architecture that has ever disfigured
any country. True it is they are more complicated, more
expensive, and less efficient, besides offering every pos-

sible obstacle to cleaning. But it was a momentous ques-
tion : something was left undone that could be done to
add to the ugliness of street architecture, so utility and

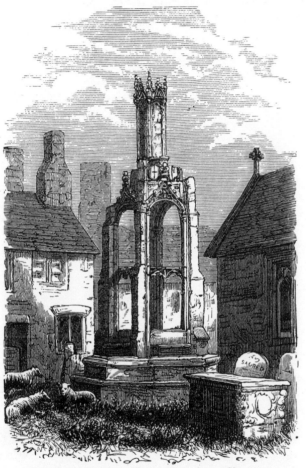

Remains of Preaching-Cross at Iron-Acton, Gloucester.

common-sense were sacrificed. These reflections naturally
follow the examination of the crosses we are considering,
which are not only convenient, but objects of great beauty.

The cross at Iron-Acton, in Gloucestershire, seems to have been designed for addressing a congregation out of doors in summer weather; the engraving can give only a faint idea of what it was originally. The stone of which it is made is very hard, and the carvings on it are perfect; but it has been mutilated designedly. The angle-buttresses were formerly terminated by pinnacles, and over the centre was the tall cross. It has evidently been destroyed by heavy missiles; there are marks on the upper part where stones have struck; but whether the remaining part was too solid for further mischief, or whether the inhabitants of the houses on the other side objected to the proceedings, we are nowhere informed. There was a light octagonal shaft, in the middle of which the base and cap are now standing; and from this sprang elegant moulded ribs, intersected by carved bosses. The work is evidently of the fifteenth century.

The preaching-cross of the Black Friars' monastery, in Hereford, somewhat resembles that of Iron-Acton; but the details of the former are richer, and the design is more elaborate. It is perhaps, at first, not obvious why the Hereford cross is more pleasing in appearance; but this arises simply from the fact of its being hexagonal instead of square. Hexagonal or octagonal structures on this scale always suit the tone and intention of Gothic architecture better than square ones. This is happily illustrated in Chester Cathedral, where the bishop's throne, which is excellent in detail, but square, is opposite the pulpit, which is octagonal, and the difference in effect is very marked. The Black Friars came to Hereford during the time of St. Thomas Canteloup, about 1280, and at first

they set up a small oratory at Portfield; but on that falling into ruin, Sir John Daniel commenced another for them,

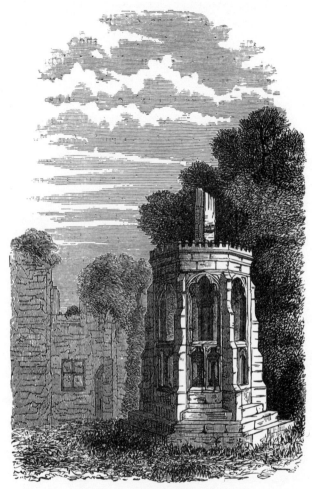

Black Friars' Preaching-Cross, Hereford.

which was finished by Edward III. Round the pulpit that is here shown were cloisters, into which the public were able to retire in wet weather without being out of

the hearing of the preacher; something, it is said, in the
style of old St. Paul's preaching-cross. In this enclosure
a great number of influential people were buried, as is

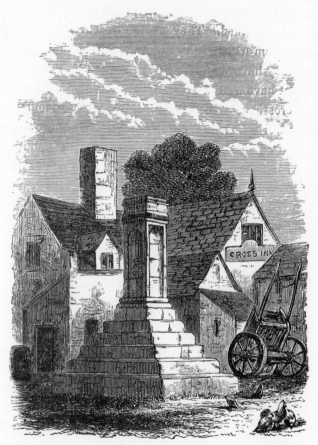

Base of High Cross at Aylburton, Gloucester.

narrated by Grose, and also by Dugdale. The monastic
buildings were destroyed, and used, in the same place, for
an asylum for soldiers and domestic servants, early in the
seventeenth century.

The crosses of Lydney and Aylburton, which are situated in a beautiful part of Gloucestershire, on the left bank of the Severn, differ much from the preceding; and it is somewhat difficult to classify them under any of the heads originally specified. They are approached by tall flights of steps, from which it is not improbable that an ecclesiastic may have addressed the rustics. The one at Lydney must have been a splendid structure when complete. These crosses are called by local authorities fourteenth-century work. There is nothing in the style of architecture to indicate their age with any kind of precision, but there is no reason to suppose the date is incorrect; history is silent regarding them. Mr. Pooley, in his excellent work on the Gloucestershire crosses, points out indications of their being designed for a foreign artist—an Italian probably; and certainly the heavy corners of the one at Aylburton would seem to confirm the supposition. Italian artists were not unfrequently employed; it is known that they were engaged by Edward I. on the Eleanor crosses.

Hempsted Cross, also in Gloucestershire, is situated in the pretty village of Hempsted, and within a short distance from Hempsted Court, the seat of the Lysons family, where the great work "Magna Britannia" was written, a book which for fidelity and exhaustiveness stands almost alone in antiquarian researches; even though it was a pioneer, and published nearly three-quarters of a century ago. This cross is very picturesque, standing in the middle of a quiet village of more than ordinary beauty. It had been partially destroyed; but Mr. Lysons, the present lord of the manor, found the pieces, and had it restored.

A little farther along, on the field-road to Gloucester city, is another cross, differing materially from those last enu-

Hempsted Cross, Gloucester.

merated, and called "Our Lady's Well." It is closed in the gable on the reverse side of that shown, has been walled

up closely in the present century, and it is commonly said to be arched with moulded ribs inside, and to have, or to have had, some carving. All the old stone-work is singularly sharp and clear in this district: it was soft when worked originally, and became indurated after a compara-

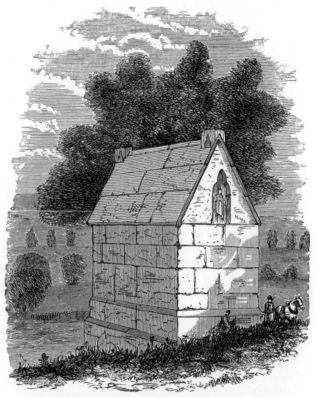

Our Lady's Well, Hempsted : Bases of two Crosses over Gables.

tively short exposure to the weather; and, like other stone of a similar kind, when once the face is chipped away it never forms again.

With the exception of the last cross named, all those

treated in this chapter might be called preaching-crosses. It is often matter of conjecture why they should have been placed in such unlikely spots; a few words of explanation will suffice, beyond those already given.

About one hundred and fifty years after the Conquest lived and flourished St. Francis, who, at the age of thirty-seven, enjoyed the title of "Seraphic Father." He was the son of a wealthy merchant: but, after a fit of sickness, disinherited himself, and set to work to establish a new order. He wore a grey serge coat, and soon was at the head of a chapter of five thousand friars, who habited themselves like him, and were called "Grey Friars." About the same time another zealous reformer, Dominic de Guzman, founded another order of friars, who dressed in black and wore a white rochet. The latter monks were the first to arrive in England, with high testimonials from the Pope; and great was the sensation they caused. They came on foot, the humility of their rule forbidding them to mount horses. They professed to want not silver, nor gold, nor lands, but felt they had a necessity laid upon them to preach the Gospel to the poor. These Black Friars, also called Dominicans, soon established a splendid monastery in London, and had a bridge over the Thames, where the present one bearing their name stands. Both these orders were called Mendicants, and even a slight acquaintance with the various brotherhoods would be useful in examining the present remains of monasteries or crosses, or indeed of mediæval architecture generally.

The Cistercians came into England in 1128, from Aumone Abbey, in Normandy, the Bishops of Winchester establishing them in the Abbey of Waverley. They might

be called a sect of the Benedictines, and were equally remarkable for the strictness of their lives. What this strictness was, we are not at a loss to gather from the records of many Cistercian monasteries: they ate neither flesh nor fowl, unless given them in alms; and built their religious houses at a given distance from each other, always selecting some secluded place. Their text was that "the wilderness and the solitary place should be glad;" and the houses of the Cistercians well carried out their text. Fountains, Furness, and Valle Crucis Abbeys, and eight hundred other buildings, were the astonishing results of their labours, of which eighty-five were in England and Wales. They went about, in the first instance, carrying preaching stands, as the Wesleyans do now in some country places; but soon established preaching-crosses as a more convenient and dignified way of addressing the people. The difficulty of finding any historical record of so many crosses arises from the fact that they were built out of the rapidly growing wealth of the orders, and were barely recorded even at the time they were erected.

There were many other orders, besides those mentioned, who were equally strict in their way of life. Well would it have been with them, and perhaps the generations after them, had they adhered to their asceticism; but unhappily increasing wealth brought increasing temptations to luxury, and the profusion of their households became a by-word. Parochial clergymen invented caricatures of them, which were even incorporated in carvings in parish churches, in sometimes nameless devices, giving accidentally a cue to some modern architects to copy in their ignorance designs that have lost their meaning.

So strict at one time was the law of the mendicant orders, that they never spoke except in preaching from a high cross; and only made signs, after their discourse, for what they wanted. How they fell away from their high standard is no part of the present work to record; but the Royal Commission found that in Furness Abbey, Rogerus Pele, the Abbot, had one more wife than would be allowed to even a layman, and two more than an ecclesiastic ought to have, as the chronicler relates; and others were enumerated who had similarly relaxed the rules. It is only fair to the Cistercians to add that they covered the country with buildings that have no rivals in any country for architectural skill and beauty; indeed, we may generally refer any large building of more than ordinary beauty to the Cistercian order.

III.

IN writing a brief treatise on the "crosses" of England, it has been found almost necessary to adapt the subject to a series of essays, as beyond a certain limit classification would become difficult; though, indeed, the next chapter, on the Queen Eleanor Crosses, will deal entirely with one portion of the subject. Could road-side crosses have remained to the present day, they would have been cherished objects in almost every village of England; but to blame wholesale the spirit that led to their destruction, would be not to make sufficient allowance for the terrible times from which all Europe was scarcely emerging. After the suppression of the religious houses by Henry VIII. there had been a vigorous attempt to re-establish the Roman Catholic religion in England, and the Inquisition was strengthened by royal favour. So far, however, was the Reformed religion from being put down, that it seemed to flourish in spite of it, and France, through four stormy reigns and the invasion of many foreign armies, was shaken to its very centre. Spain was at this time, perhaps, the most powerful country on the Continent of Europe, and resolved to put down the Reformation, even in its most incipient aspects, and that by the Inquisition. Here it may be well to con-

sider what the Inquisition was. There was nothing new in
the idea of an inquisition ; it was established in France,
Italy, Germany, and Portugal, and also in England. We
all remember how, in "Marmion"—

> "that blind old abbot rose
> To speak the chapter's doom ;"

and after hearing all that could be said, his—

> "doom was given.
> Raising his sightless balls to heaven :—
> ' Sister, let thy sorrows cease ;
> Sinful brother, part in peace ! ' "

And then the executions took place, in the picturesque
language of Scott, while the abbot and chapter hurried up
the winding stair. "But the Spanish Inquisition," accord-
ing to Schiller, "came from the west of Europe, and was
of a different origin and form ; the last Moorish throne in
Granada had fallen in the fifteenth century, but the Gospel
was still new, and in the confused nature of heterogeneous
laws the religions had become mixed. It is true the sword
of persecution had driven many thousand families to Africa,
but a far larger portion, detained by the love of climate
and home, purchased remission from this dreadful necessity
by a show of conversion." And indeed, while the Moham-
medan could offer up his prayers in private towards
Mecca, and the Jew could still pray with his face towards
Jerusalem, Granada was not subdued, and Jews and Mos-
lems were lost to the throne of Rome. So now it was
decided to extirpate the roots of their creeds, their man-
ners, and their language ; and the Inquisition, called the
"Spanish" Inquisition, was established. It has received
this name in order to distinguish it from all other inquisi-

tions by its wickedness and cruelty; indeed we may search all the annals of history for its prototype, and happily we shall search in vain. The moment a suspected party, in fact, any one that even doubted the impeccability of the Pope, was pointed out, his fate was sealed: he was led in mock procession under the bright skies of Spain; bells were jangled out of time and tune; priests sang a solemn hymn: and with yellow vestments, painted all over with black devils, with a gagged mouth, without sometimes knowing the name of his accuser, or even his particular crime, he was led to his execution. This Inquisition soon spread through Portugal, Italy, Germany, and France, and even India was not long free from its powerful arm. England, of course, was particularly obnoxious to it, and in order to its establishment on these uncongenial shores, the Spanish Armada was equipped and sent. Indeed, when the order went abroad from parliament for the destruction of crosses as pertaining to the Romish Church, it should be remembered that men were still living who had known galley after galley go to the bottom of the English Channel with its racks and screws on board. Of course all this cannot excuse the destruction of crosses by the Puritans; who, indeed, in their turn, were equally illogical, and in many important things as bigoted as the parties they oppressed.

The " Percy Ballads " contain an excellent satire upon the destruction of Charing Cross. The edition published in 1794 says, in the introduction to this ballad, that Charing Cross "was one of those beautiful obelisks erected by Edward I., who built such a one wherever the hearse of his beloved Eleanor rested on its way from Lincolnshire

to Westminster. But neither its ornamental situation, the
beauty of its structure, nor the noble design of its erection,
could preserve it from the merciless zeal of the time."
And then it proceeds to show how even the quiet people
of those times looked upon its senseless destruction :—

"Undone, undone, the lawyers are,
 They wander about the towne,
Nor can they find their way to Westminster
 Now Charing Cross is downe ;
At the end of the Strand they make a stand,
 Swearing they are at a loss,
And chaffing say, That's not the way,
 They must go by Charing Cross."

From another part of this clever satire there seems to have
been an inscription on this cross ; for the writer protests
that it could not have had any treasonable designs, as it
never was heard to speak one word against the parliament.
He says—

"For neither man, nor woman, nor child,
 Will say I'm confident,
They ever heard it speak one word
 Against the parliament.
An informer swore it letters bore,
 Or else it had been freed ;
I'll take in troth my Bible oath
 It could neither write nor read."

Lydney Cross, in Gloucestershire, is situated not far
from Aylburton, already mentioned, which it must have
somewhat resembled, though it stands on a higher flight
of steps, and is more imposingly situated at the end of the
road leading into the village. What the original form may
have been it is not easy now to determine, but the base
seems well adapted for the support of a good cross ; it was
probably brooched into an octagon on the next stage, and
finished with tabernacle-work. Lydney was granted to

Sir William Wintour, who did such good service in the time of the Armada; he built a house there, which was destroyed during the civil wars, when the cross was dis-

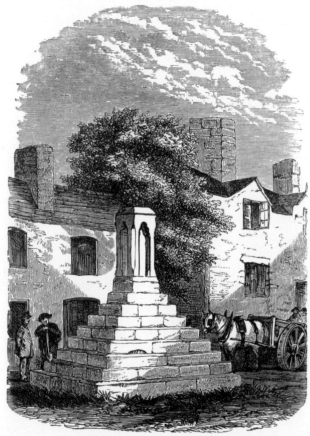

Lydney Cross, Gloucester.

mantled. The manor was afterwards purchased by the Bathurst family, who built Lydney House in one of the most beautiful parks in Great Britain.

Bisley Cross, also in Gloucestershire, is unlike any in

England. It is called by so careful a writer as Britton,
a preaching-cross; but this must be a mistake. Indeed, it
is not certain, from his notice of it, that he had seen it; he
appears rather to mention it as a specimen of crosses in

Cross in Bisley Churchyard, Gloucester.

general, which was a subject he promised to take up when
time permitted—which, alas! it never did. Bisley Cross
has all the appearance of having been erected over a well
in the churchyard; but there is no trace of a spring now.

Perhaps, however, the water may have dried up, as is not uncommonly the case in that stratum; this is the more probable, as one of the late Mr. Lysons' plates shows

White Friars' Cross, Hereford.

the cross crowned by a sort of font. Bisley is one of the most ancient crosses—excepting those at Sandbach—of which we shall have occasion to speak. It must have been built, according to its mouldings and its general

appearance, about the year 1170. It stands on a circular
basement, upon which are six upright shafts forming a
hexagon: these again support six cusped arches with
Early English mouldings, and are terminated by bold
Early English heads; fillets run up each angle and stop
very singularly in a bevel, about half-way up; this hexa-
gon supports again six smaller arches with very deep
mouldings. The general appearance of the work resembles
Peterborough and other Early Pointed specimens.

White Friars' Cross, near Hereford, stands about a mile
from the city; the upper part is new, though built pro-
bably in the style of the old. There was formerly a market
held here. The cross was built by Bishop Charlton at the
time of a great plague in Hereford; but there are no traces
left of the plague-stone, which contained the hollow for
vinegar, in which the money was placed. This is a very
valuable and beautiful specimen of a roadside cross, and
must have resembled Lydney when the latter was perfect,
only that it is richer and more elegant in workmanship.

Clearwell Cross, in Gloucestershire, is generally attri-
buted to the fourteenth century; it is on a square base
which rests on large square steps, as shown in the woodcut,
and is a very characteristic specimen of the ordinary road-
side cross of that district: in other parts of England
different forms prevailed, and the light tabernacle work is
common. The general form of these crosses may be
described as tall shafts (monoliths) resting on a base like
that at Lydney, Clearwell, or Hereford, generally square,
but occasionally hexagonal, and diminished by brooches:
on this shaft was carved the cross, in many instances, but
in others a wrought-iron cross was substituted, which was

fixed on iron hooks driven into the monolith; some of these hooks still remain.

Tottenham Cross, again, is a type of a totally different kind, and is here introduced as a contrast. The present

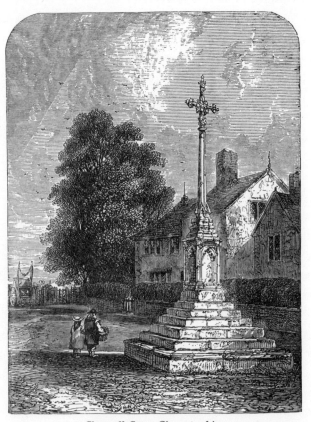

Clearwell Cross, Gloucestershire.

structure is comparatively modern—or at least it is the old cross cased round. The ancient cross is familiar to us rom old-fashioned prints, in which the earlier Georgian dresses appear, and also mail-coaches; it belongs to the

type of solid crosses, like miniature spires. These seem to prevail more in the eastern counties, and of them the Eleanor examples are pre-eminent among all others in the kingdom for their grace and beauty. Greatly inferior as this cross is in every way to the Eleanor crosses, it is a pleasant object by the roadside.

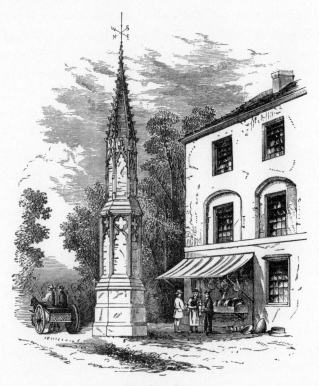

Tottenham Cross.

As we have before remarked, there are other forms of crosses peculiar to certain localities, and, as a contrast to each of the last-named, is the cross with the tabernacle-head, like the " Chester Cross," engraved on page 7—not

that even these are confined to any strictly laid-down limits; thus there is one at St. Donato, Cornwall, one at Cricklade, Wiltshire, one at Henley-in-Arden, Warwickshire, and there are more at other places. It is a pleasing fact to be able to announce that a beautiful tabernacle-head to a cross has been discovered in the middle of Cheshire.

The last cross we shall notice in this chapter is a very curious one at Oakham. Britton mentions four oak market-crosses as standing at the beginning of this century; and doubtless in counties where oak-trees were plentiful these crosses were once numerous: but to this one at Oakham he has not alluded. It is an interesting and extremely picturesque object, standing on eight square blocks of stone, on which are as many upright oak posts; a beam goes from each and rests on the head of its neighbour, being supported by small struts; and in the middle is a very solid pier, with two steps or seats for the market-people. There is another oak market-cross in the same town, but it is square; and, though apparently of the same age, is far inferior in picturesqueness to the one we engrave. Oakham is an exceedingly interesting county town, and is not visited so much as it deserves. It formerly belonged to the Earls Ferrar, who exacted tribute from all barons passing through; in later times this was often commuted into the payment of a horseshoe (the arms of the family); some of these are still hung up in the Town Hall, and are of enormous size. The Town Hall was formerly a part of the family mansion. If this cross be considered only a variety of such as Chichester and Malmesbury, we shall then have taken a brief survey of all kinds of crosses in England.

Inscriptions on crosses were formerly common, and alluded either to the piety of the founder, for whom prayers were invoked, or reminded passers-by of their duty. The old cross at Wavertree village, near Liverpool,

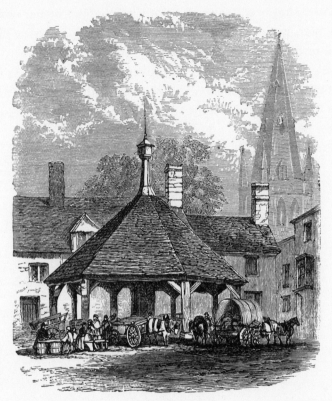

Oakham Market-Cross.

is pulled down, but the well and the inscription remain :—

"QVI NON DAT QVOD HABET
DÆMON INFRA RIDET ; "

which has been translated in Bain's " Lancashire " into the

following almost literal couplet :—

> " He who does not here bestow,
> The devil laughs at him below ; "

and, indeed, other remains show almost equally broad
hints for the contributions of the faithful. The Eleanor
crosses, however, which will form the subject of our next
chapter, were only put up for the prayers of passers-by for
the rest of the soul of the queen.

Sir Walter Scott, in his last canto of " Marmion," thus
alludes to the inscription on the cross and well where the
Lady Clare went for water to bathe the head of Marmion
after his wound :—

> " Behold her mark
> A little fountain cell,
> Where water, clear as diamond spark,
> In a stone basin fell.
> Above, some half-worn letters say,
> *Drink, weary pilgrim, drink ; and pray*
> *For the kind soul of Sybil Grey,*
> *Who built this cross and well.*"

MONG all the memorial crosses in Europe, those of Queen Eleanor stand alone. Their beauty of proportion, their variety of design, the ideas which they have suggested to modern architects, and the touching story of their erection, give them undisputed pre-eminence.

Queen Eleanor was espoused to Edward I. in 1255, in the tenth year of her age, he himself being but five years older. This espousal took place during the visit of the prince to Alfonso X., King of Castile. She remained in France till her twentieth year, and then went over to England to join Prince Edward, living principally at Windsor. Here their two eldest sons were born, who gave great promise from their intelligence and beauty. Another son was also born before they left on their ever-memorable expedition to the Holy Land; on their return they learned, while staying with Charles of Anjou, that their two eldest sons were dead. Another was shortly after born, and named Alfonso, after Eleanor's brother; he is said to have been more promising even than the others, but he also died very early. They had in all fifteen children, and of these six survived. Queen Eleanor accompanied her husband in all his expeditions

and wars—the Holy Land, Wales, and Scotland; it was her tact and exceeding amiability that assisted him to pacify the malcontent Welshmen. Rhuddlan Castle and Caernarvon were alternately her residences, and Conway at a somewhat more recent date.

No one can be surprised, after a brief perusal of the reign of Edward, that his devotion to his queen was so great. She entered into all his schemes, was beloved by his subjects, in whose welfare she always took an interest, and her sweet beauty is immortalised by Pietro Cavallini in the well-known monument at Westminster.

Queen Eleanor died at Harby, or Hardeby, in Nottinghamshire, while travelling northward to join her husband in his Scottish wars. She was seized with a dangerous autumnal fever, and though Edward, immediately on hearing of it, turned southward, he never saw her again alive. Nothing more singularly illustrates the looseness with which authorities are quoted, than the difficulty that has been experienced in arriving at the actual route the body of Queen Eleanor was taken in its last journey. She has often been said to have died near Bolingbroke, in Lincolnshire, but many circumstances point to Hardeby as being the actual place. She died at the house of a gentleman named Richard Weston, but every trace of the house and the family has now disappeared. The queen may probably have been on her road to Broadholme Priory, only a few miles distant.

Her illness seems to have been rather lingering, for we read that on the 18th of October, or six weeks before her death, a mark (13s. 4d.) was paid to Henry of Montpellier for syrups and other medicines for the use of the queen;

rather a considerable sum in those days, though there is much difficulty in arriving at the value of money at that period; at least, the common method of computing it as worth ten or twenty times as much then as it is now (both of which estimates are maintained), is exceedingly vague. Thus it is said that William of Wykeham only received 1s. per day for his work at Windsor Castle, with an extra shilling per diem for any other work he was employed on for the king. This, however, was to include all travelling expenses; although, probably, he had never far to go. There is a singular calculation that for long journeys, such as from London to Carlisle, the nominal sum, if luggage were included, would fully equal that paid at the present day, which alone will give us an insight into the enormous cost of travelling in ancient times, and perhaps account for country towns, even up to the present day, bearing traces of having been centres of social "seasons" for families of rank. We must not, therefore, infer that 13s. 4d. was an exorbitant bill, or that it indicated any very serious overcharge on the part of the Lincoln apothecary, for we cannot tell what he had to pay for the medicines. The queen was attended by her own physician, who bore the Spanish name of Leopardo, and also by a brother-doctor, who held a high position in the court of the King of Aragon.

There are those who maintain that King Edward was simply on a hunting expedition, and not proceeding to the Scottish wars; of this they say that the meeting of the parliament at Clipston, where he had a mansion, and where his signature appears to documents, is ample evidence. In support of this view, he is traced from Geddington to

Macclesfield, in Cheshire—which, indeed, lies near Dele-mere Forest, and is still crown property: but the probability is that the documents alluded to were signed some days, or even weeks, after they were executed.

Queen Eleanor died on the 28th of November, 1291. A cross was erected at every resting-place of her funeral procession on its way to Westminster. There was nothing particularly new in the idea; it was only an extension of the lich-gate system, for a corpse always rested under a "lich," of which there are many left in every county in England; and, indeed, these resting-places are quite ana-logous to the Eleanor crosses. On the road from Paris to St. Denis, the last resting-place of so many kings of France, crosses were erected at almost every few hundred yards—all, however, to be swept away at the Revolution; indeed, by a decree of 1793, more than fifty tombs were destroyed at the grand Abbey of St. Denis.

The places where Queen Eleanor's body remained for the night have been numbered at fifteen, but probably only twelve of the so-called Eleanor crosses were erected. The distance from Hardeby to Westminster, by the old roads, was one hundred and fifty-nine miles; and if thirteen and a half miles were accomplished each day by the melancholy procession, that would be a considerable journey; the season was winter, and the roads in the east of England were very bad. We believe, after much research, that the sites of the crosses were Lincoln, Grantham, Stamford, Geddington, Northampton, Stony-Stratford, Woburn, Dun-stable, St. Albans, Waltham, West Cheap, and Charing.

The queen's heart was deposited in the church of the Friars Prædicants in London, and the bowels in the chapel

of the Virgin in Lincoln Minster, where there is also a
statue to her, and another to her husband, both of singular
beauty and dignity.

The funeral procession set out on the 4th of December,
and arrived at the end of its memorable stages on the 17th.
After leaving Stamford, the ordinary route was abandoned,
to enable some of the religious houses to be visited; and
it seems that, after leaving St. Albans, the king hastened
on to London in person, and met the procession on its
entrance into the city.

All the Eleanor crosses have disappeared except those of
Geddington, Northampton, and Waltham; these three are
fortunately in a state of good preservation. Their variety of
design suggests that they are not the work of the same hand.
Geddington cross is unlike any English Gothic architecture;
indeed, it has so much the appearance of the architecture of
Spain at that period, as to make it probable that it was the
work of one of the queen's own countrymen. It is tri-
angular in plan, and, as will be noticed, the fronts of the
figures face a mullion, unlike the other crosses; suggesting,
indeed, rather a caged look. But this is not the most
awkward part of the design, for it will be seen that, if
viewed from an angle, the whole structure is of necessity
off the centre. The diaper patterns, which are illustrated
in the fifth edition of Rickman, are eight in number; as
will be seen, they cover the whole of the lower stage of the
cross. They are exceedingly well engraved in Rickman's
work (apparently by the late O. Jewitt), and are in them-
selves of great beauty. This cross is erected over a spring
of clear water, which never runs dry.

That Geddington should have been chosen as a resting-

place is not to be wondered at, as it is certain that a considerable royal palace stood there. Though this beautiful Northamptonshire village is now but little known, and

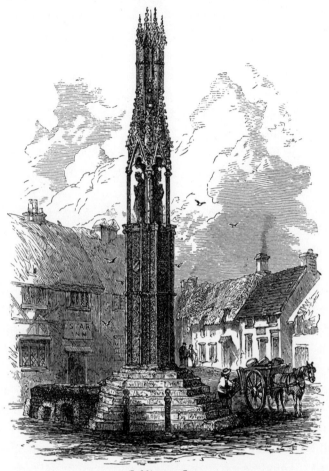

Geddington Cross.

even that little chiefly from its cross, parliaments have discussed and passed weighty matters there in ancient times. Henry II. here decided on the expedition to the

Holy Land, and many articles concerning the voyage were concluded. Stowe says, "the whole realme was troubled with taxes" in consequence—all decided on at this little hamlet. John also held parliaments here, and dated many charters from it. Every trace of this palace has passed away, though there is a field on which it stood, which still bears the name of the Hall Close. The little inn, the

Plan of Geddington Cross, Northampton.

Star, which is close by, bears traces inside of having been part of a "considerable house of great antiquity." The two posts shown in the woodcut are part of the village stocks. From an old print, published in 1788, it seems that the third story of the cross was utilised for a sun-dial.

From Geddington the cortége went to Northampton, which it reached on the 9th of December, the distance of this stage being about nineteen miles; the road is exceed-

ingly beautiful, and passes by the seats of the Duke of
Buccleuch and Lord Overstone. Northampton Cross, un-
like Geddington, is octagonal in form, and is in an

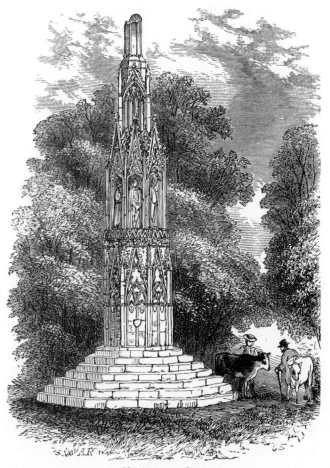

Northampton Cross.

exceedingly fine state of preservation; it stands about a
mile from the town, on the London road, in a large recess
in the park wall of Delapre Abbey, the seat of the Bouverie

family. Northampton has many ancient buildings, edifices
which were two hundred years old even when Queen
Eleanor's remains rested there; it must have been a place
of comparatively much greater importance in those days
than it is now. This cross has been perhaps less often
copied than Waltham, but it is not inferior to it in beauty
of design. The Martyrs' Memorial at Oxford, designed by
Sir G. G. Scott, is a combination of the two. The female

Plan of Northampton Cross.

figures are exceedingly graceful and light. Queen Eleanor
must have been above the average height, and a wonderful
example of feminine beauty. The top of this cross is
broken off exactly as it is shown in the engraving; from
the general appearance of the design the shaft probably
ended in light pierced gables, with pinnacles between, and
from this the cross started : happily no modern architect
has been commissioned to attempt its restoration. The
plan of the cross, which is here shown, is curious, and

very ingenious, and resembles one of the snow-crystals, except that the latter are always hexagonal. The plans of the crosses ot Geddington and Northampton, in their various angles, offer a contrast of design to Waltham, which is hexagonal, so that the three crosses left to us are all of different plan, and differ even as to the number of their sides. In a recent and interesting work called " Art-Studies from Nature, as applied to Design," * there are a number of snow-crystals shown ; so closely do these resemble in character the plan of an Eleanor cross, that they might readily be adapted by an architect; by running up perpendiculars from their angles they would suggest new forms with unerring certainty ; indeed, this idea seems to have been present to Mr. Glaisher when he wrote the article which that work contains on these snow-crystals.

From Northampton the procession went to Stony-Stratford. This is a stage of only fourteen miles, the route lying through Blisworth, Road, and Grafton Regis. Every trace of the cross has disappeared, nor can we find where it stood.

The next place on the route to London was Dunstable, which lies nineteen miles farther off; here, as in the last place, all traces are gone. Tradition yet speaks of the glory of this structure, which was built near the present Town-Hall. Camden says of it that it was a cross, or pillar, adorned with the arms of England, Castile, and Ponthieu, and bearing carved statues of the queen. The procession would thus pass by Fenny-Stratford and Wo-

* " Art-Studies from Nature, as applied to Design. For the use of Architects, Designers, and Manufacturers." Profusely Illustrated. Virtue & Co., Ivy Lane, Paternoster Row.

burn, through Watling Street; but as Woburn Abbey is two or three miles off the London road, and only ten from Stratford, which they had left in the morning, it is not apparent why they should stay there for the night, especially as the abbey was deserted by the monks in 1234, in consequence of the scanty endowments, and was not opened again till the end of the century; still, however, tradition assigns here some wayside monument to the queen. The road from Dunstable to St. Albans is only twelve miles long; it passes through Kensworth and Red-burn, and lies in a very pleasant country.

The Abbey of St. Albans was of great dignity in those days, and naturally the procession would rest there before proceeding. It had entertained Henry I. and Queen Maud nearly two hundred years before, on the occasion of its consecration, keeping up festivities for eleven days. The church of that period is still standing, built of Roman hewn stones.

The last resting-place of the body before entering the precincts of London was Waltham. Waltham Cross is certainly one of the most precious inheritances we have from the architecture of the Middle Ages. On an old print of this cross, dated 1718, is the following inscrip-tion :—" Waltham Cross, here represented to ye N.E., was one of the crosses erected by King Edward I., about ye year 1291, in memory of his consort, Queen Eleanor, dar. of Ferdind. 3$^{d.}$, K. of Castile & Leon, whose arms are cut on the lower part of this cross, as are those of ye Countess of Pontieu, her mother, & also of England." In another print of apparently the same date occurs the following :—" In memory of Queen Eleanor, the beloved wife of that glorious

monarch, who accompanied him to the Holy Land, where
her Royal Husband being stabbed with a poisoned Dagger
by a Saraycen, and the rank wound judged incurable by

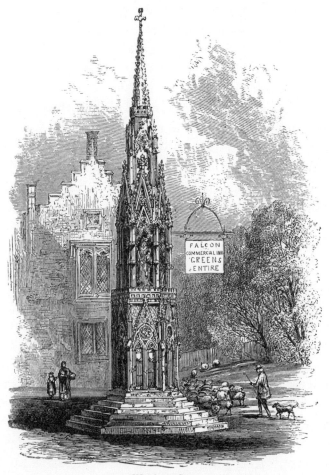

Waltham Cross.

his Physicians, she, full of Love, Care, and Affection,
adventured her own life to save his, by sucking out the
substance of the poison, that the wounds being closed and

citracised, he became perfectly healed." Farther on the inscription says that roadside crosses were erected at "Lincoln, Grantham, Stamford, Giddington, Northampton, Stony-Stratford, Dunstable (now destroyed), St. Albans, and this at Waltham, being the most curious in Workmanship, Tottenham & Westminster, now called Charing Cross."

The words "now destroyed" are encouraging, for it would imply that some traces of all the crosses but that at Dunstable were to be found when this print was published. We have seen how the burying of Chester Cross saved it in the seventeenth century; in the same way a foot of earth may be hiding some of the others. "Tottenham Cross," as already mentioned, is not an Eleanor cross.

Waltham Cross has been more often copied than any one remaining in England; it has been excellently imitated on a much larger scale in the Westminster Crimean Cross, near the Abbey: perhaps the only fault being the comparative weakness of the lower story: but it is the best modern cross in England. From Waltham to London, through Tottenham, the road is well known.

Cheapside Cross was demolished by order of Parliament in 1643, but this was not the original one erected by Edward in memory of his queen, which fell into decay, and was supplanted by another in 1486. This again crumbled, and was rebuilt in 1600, in the Elizabethan style. There is a well-known print of the demolishing of Cheapside Cross, published not long after the event, and the circumstance was satirised in the "Percy Reliques."

Charing was the last stage where the body rested. There is a very fair engraving of the cross,—taken from a drawing

mentioned by Mr. Pennant in his last edition of " London,"
page 93,—now in the British Museum, and published in
1814 by Robert Wilkinson, a London bookseller. Though

Charing Cross, from the Crowle Collection, British Museum.

this engraving is far from accurate, there is so much resem-
blance to the other crosses that, in all probability, it gives

a tolerably fair idea, however faint, of the original structure. The cross gave the name to the locality, having been erected for the " beloved queen " (*chère reine*). The wood-cut here given carries it out in its perfect entirety, only altering, and that indeed very slightly, some few obvious inaccuracies in the details of a kind of architecture then not reduced to precise styles, but which is now thoroughly understood by all true architects.

V.

E have already remarked that covered market-crosses were simply sheltering places for country-people who came with their goods to the nearest market-town; and small as they may seem to our present notions, they were amply sufficient for the wants of their day. Religious houses were mostly near, and as the nave of the church was open invitingly to all comers, it afforded shelter to these who had disposed in good time of their produce; the same thing may be seen now in Catholic countries. The custom has indeed even followed the "Habitans" of Canada across the ocean; these are one and all Roman Catholics, and very simple and devout. They are descended from the old French families who first peopled Canada, and adhere fondly to their language and ancient traditions. There are many roadside crosses along the lanes leading to Montreal. It is really a pleasant sight to see the country-people hurrying off, after selling their market-produce, either to the old church of Bonsecours, about one hundred and eighty years old,—a great piece of antiquity for those regions,—or the more pretentious and really vast church of Notre-Dame, in the French square of that city.

At one time similar scenes might be witnessed in all the

old English towns. Malmesbury must have been a very picturesque place in the time of Leland, who visited it just before the dissolution of the monasteries. He describes it with great conciseness and accuracy, and thus writes of

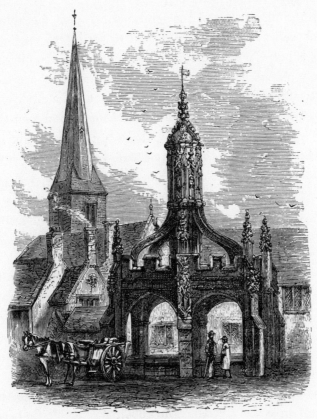

Malmesbury Market-Cross.

the fine old cross that is here illustrated :—" There is a right faire and costly piece of worke in the market-place, made all of stone, and curiously vaulted, for poor market folks to stand dry when rain cometh. There be eight

great pillars and eight open arches, and the work is eight square; one great pillar in the middle beareth up the vault. The men of this towne made this piece of work *in hominum memoriâ.* Malmesbury hath a good quick market, kept every Saturday."

On the dissolution of the monasteries, when the abbey offices were sufficiently demolished to satisfy the spoilers, "one Stumpe, a rich clothier," prevailed upon the king to let him purchase the grand old church, which he converted, along with the remaining offices, into a cloth-factory : and though we might be disposed to find fault with him for the base uses to which he put it, there can be no doubt he saved the church for the town of Malmesbury.

An interior view of the cross, on an enlarged scale, is also given, showing the style of the vaulting. It was not a covered market, which is a more recent invention, growing out of these beautiful covered market-crosses, as in the cases of Ross and Shrewsbury, which are illustrated in this chapter ; perhaps the edifice at Shrewsbury hardly belongs to market-crosses, though it was the immediate result of them. The available space for standing under cover in Malmesbury Cross is some three hundred feet, or a little less ; there are two openings which reach to the ground out of the eight arches.

Malmesbury had been a market-town long before the present cross was erected. The abbot, William de Colhern, who died in 1296, built a market-cross there, though no vestige of it now remains ; he also developed the resources of the abbey with great energy, dug fish-ponds and planted vineyards, taking care to establish a sort of founder's day for himself and his father and mother. For this day, as it

annually occurred, he set a sum aside to purchase a butt
of wine for the use of those who would pray for the rest of
his soul. His name was long and favourably remembered

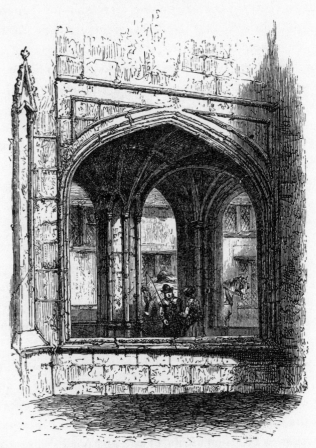

Interior View of Malmesbury Market-Cross.

by many devotees; a goodly congregation might always
be calculated upon as a certainty on the anniversary. The
butt of wine he added, with much simplicity and candour,
would enable the people to pray more fervently.

Fortunately, Malmesbury Cross is in an excellent state of preservation, and Leland's description is as accurate as any we could write at the present time, though when he saw it in Henry VIII.'s reign the cross was one hundred years old. It is to be regretted that there was no Cattermole or Prout in those days to paint the wonderfully picturesque scenes that every portion of Malmesbury Abbey must have presented in those curious times, when the workmen were told off for making the various kinds of cloth prescribed by sumptuary laws for each class of society, all these fabrics being wrought in grand old vaulted chambers.

The proportions of Malmesbury Cross are different from any of the other covered market-crosses in the south. It is remarkable for its heavy lantern, and the curious way in which this lantern is made even to give solidity by throwing greater weight upon the pillars, which serve in their turn as abutments for the groining of the interior. Many of the old buildings near the cross belonged originally to the dismantled abbey, but, in their present character, they are changed out of all knowledge.

Chichester market-cross is the most elaborate and imposing in England. It would seem, by its mouldings and general appearance, to belong to a somewhat more recent date than Malmesbury, though if Leland's *in hominum memoriâ* is to be taken in its literal, and not its figurative sense, that cannot well be. The plan of Chichester Cross is so nearly identical with that of Malmesbury that it has not been considered necessary to give the latter; the only material difference being that in Chichester all the eight sides are open to the ground, while in Malmesbury a low

kind of plinth walling, on which the rustics may be seen
sitting, encloses six of its sides. Though Chichester is
more imposing, and covers more ground, Malmesbury is

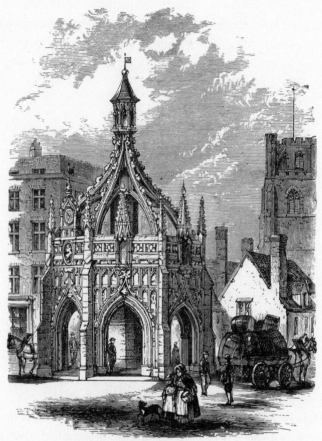

Chichester Market-Cross.

much more elegant in its proportions, with the additional
advantage of being more picturesquely surrounded. Chi-
chester affords about four hundred square feet of standing
room ; this space was not generally used for farm-produce,

which mostly came to market in covered waggons having waterproof tops, as we still see covered carts in most rural parts of England.

Chichester Cross was built by Edward Story, who was advanced from the see of Carlisle to this more genial part of the country by King Edward IV., in the year 1475. It was repaired in the reign of Charles II., by Charles, Duke

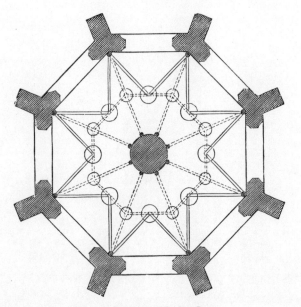

Plan of Chichester Market-Cross.

of Richmond, Lennox, and Aubigny; though perhaps there may have been a little laxity in the disposal of the fund left by the bishop, for he certainly bequeathed an estate of £25 per annum to keep the cross in repair; a very ample sum indeed, to judge of money at its then value, of which, as before stated, there is not only much uncertainty at the present time, but even much contradiction. The clock is

recent, and only dates back to 1724. "There is," says
Britton, speaking of this cross, " a degree of grandeur in
design and elegance of execution superior to anything of
the kind in England. The canopied arches, tracery on the
surface, sculptured cornice and frieze, with the purfled
pinnacles and flying buttresses, show both taste in the
architect and science in the mason. This cross, of course,
stands in the middle of the city, as was the proper custom
in all old market-crosses." It may seem hypercritical to
suggest a fault in such a beautiful structure, but even with
every desire to acknowledge the general excellence of the
design, we cannot but think that the story above the
octagonal space is somewhat heavy, and seems rather to
have the effect of crushing down the arches on which this
beautiful cross rests. Unhappily, the surroundings of
Chichester market-cross lend it but little picturesqueness,
as the whole city has been modernised to a very consider-
able extent. Some pleasant houses are still left round the
cathedral, where church dignitaries reside, but the city in
itself is very much changed.

The next illustration, carefully reduced from a fine old
engraving, is of a market-cross at Ipswich. Unfortunately,
the cross was demolished during the present century ;
otherwise it would have formed a valuable addition to the
antiquities of England. It stood opposite to the old Town
Hall, an exceedingly picturesque building, which was
also removed a few years ago.

On the top of Ipswich market-cross stood a gigantic
figure of a female with scales, probably intended to remind
the rustics who sheltered under it that they must be true
and just in all their dealings. The cross was octagonal, and

very richly and quaintly carved. The elliptical arches that
supported the roof stood on Doric columns of excellent
proportions; the roof, ogee in form, was covered with lead.
There is a singular resemblance in the character of the
ornamentation to that of the well-known "Sparrowe's
House," in the same town, of which Mr. Taylor, in his

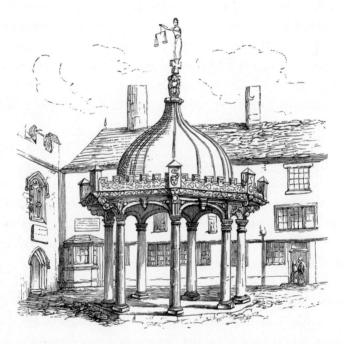

Ipswich Market-Cross.

excellent guide to Ipswich, says, "The style of ornamenta-
tion, so lavishly bestowed on the exterior, is that known
as 'pargetting,' and is one not uncommon in old Suffolk
houses of about the beginning of the sixteenth or the end
of the fifteenth century." Probably this old house and the
cross were nearly contemporaneous: the former, it is

known, was built by George Copping in the year 1567, and then this interesting city mansion fell into the hands of the Sparrowe family, who occupied it from generation to generation until within a few years since. The last of the Sparrowes who resided in it was the town-clerk of Ipswich.

The cross here given would be an excellent model for the recently projected cabmen's and carrier's sheltering-places, which are now springing up in many towns in England; and should such a structure be required in Ipswich, the 'present generation will have the melancholy satisfaction of knowing that a beautiful one was destroyed within the recollection of some persons now living. They cannot build a more commodious one, they cannot possibly contrive one so interesting, and they are very unlikely to erect such a picturesque one.

The market-cross of Ross, in Herefordshire, is hardly of the nature of a cross, but is more of a covered market-house of modern days; and, indeed, it will be the latest we shall have occasion to notice. It is divided into two gables, which cut it in two, and is open on each side; the octagonal form has become quadrangular, and there is a hall over the market. Although the building has a very venerable appearance, it is not in reality older than Charles II.'s time; there is a medallion of that monarch on the front to the street.

This market-place is built of soft red sandstone, very similar to that of which Chester Cathedral is constructed; the stone is in a state of disintegration, and it is owing to this circumstance that it has so venerable an appearance. It stands at the head of a steep, beautiful street, in a lovely country town on the river Wye, and is directly opposite to

the house of the "Man of Ross," now converted into two shops. There is a curious monogram of the Man of Ross on the opposite side to his old house, which tradition and

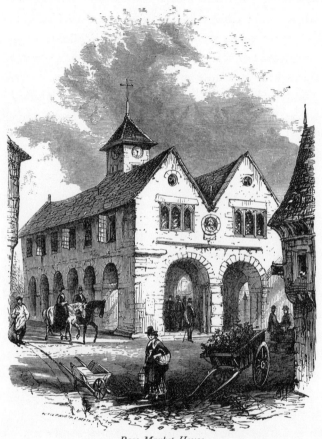

Ross Market-House.

fervid imagination have translated into the somewhat tame legend, "Love Charles in your heart."

Shrewsbury is familiar to nearly every one who travels in England; it is a delightful old city, full of historical

associations. The ancient market-hall, here shown, is not so venerable-looking a building as the one at Ross, though considerably older; but the stone of which it is built is more durable. It is by far the most imposing specimen we have left of this kind of building in England, although, like Ross, it can perhaps hardly be called a market-cross.

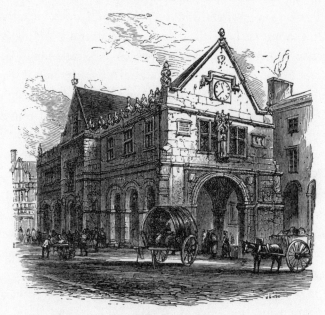

Shrewsbury Market-Place.

It was built in the year 1596, and is used at the present time on market-days, being sufficiently large for the requirements of a town like Shrewsbury. The standing-room for market-people is fully three hundred square yards. A very large market has, however, been recently erected in the vicinity in addition to this.

Shrewsbury market-house, though good in design, is

rather debased for the period, the moulding and general ornaments being more like those of the reign of Charles I.; there is a curious kind of scroll along the sides, which takes the place of battlements, and is rather heavy in appearance. The houses round the market-square have, in a great number of instances, been modernised, but there are still some fine specimens of antiquity left.

There is a curious and very beautiful open octagonal pulpit, apparently of the fourteenth century, standing in a vacant space in Shrewsbury, which has sometimes been taken for a preaching-cross, like Hereford; but it is, in reality, only part of the old abbey that has had the good fortune to survive destruction. The *High Cross* of Shrewsbury has long been destroyed, but its place is pointed out in old documents. Unhappily, it is not connected with pleasant associations, for before it the last of the British princes, David, a brother of Llewellyn, was cruelly put to death by Edward I.; and at a later period many of the nobility who were taken at the battle of Shrewsbury were there executed, the High Cross being considered the most appropriate place for such a spectacle.

At one time Shrewsbury market-place was the principal exchange for the sales of Welsh flannels, and its extraordinary size may thus be accounted for; but, with alterations in the way of conducting business, this advantage has left it, and it is now entirely a farmers' market-hall. It is almost needless to add that the clock in the gable is not, as many visitors suppose, the celebrated Shrewsbury clock to which Falstaff alludes; that is the clock of St. Mary's Church, on the other side of the town.

The gables of Shrewsbury market-cross are generally

allowed to be well-proportioned, and the outline of the structure is exceedingly picturesque ; exception may be taken to the exceeding coarseness of the curves of the enrichments, but this fault belongs entirely to the age in which it was erected.

In nearly all those places where the market-crosses just alluded to were built, there cannot be a question but that more ancient ones preceded them ; the various accounts of meetings at the cross, and even of legal documents being sometimes described as executed there, would confirm this.

There are covered markets now in almost every city or town of any importance in England. In Chester a new and very capacious market-place has been built in what is commonly called Northgate Square ; it joins the Town Hall, and presents a gable only to the road, but it has not superseded a meat-market that still stands in the square, perfectly detached, and is only open once a week. In York there is not even yet a covered market, but the farmers come as of old in covered carts, and bring their produce ; it is true, indeed, that some of the inhabitants have moved for a new market, and have urged the site to be that of the ancient parliament house and some curious buildings at the lower end of Samson Square, by which proceeding a fine block of old domestic architecture would be destroyed. But better counsels have prevailed in the meantime, and let us hope that, through the increasing interest now manifested in the question of preserving old monuments, such desecration will not be allowed ; for surely there is room enough in Yorkshire to build covered markets, and yet to spare the few hundred yards of ground whereon these old relics stand.

HE Cross of Newark, which forms the subject of the first illustration to this chapter, has often been erroneously called an Eleanor Cross; it is apparent at a glance that it belongs to a much later style of architecture. It was built by the Duchess of Norfolk, who married John, Viscount Beaumont; he was slain at the battle of Towton-Moor, in Yorkshire.

That England should have been the scene of the most fearful battle-fields seems now almost incredible; but we are so familiar with the vivid pictures Shakespere has given of the wars of the Roses, that they appear, as we read him, more real than even the comparatively recent struggles of the Commonwealth. The great battle of Towton, which took place March 29, 1461, is thus described by Hall:—"This battle was sore fought, for hope of life was set on side on every part, and taking of prisoners was proclaimed as a great offence; by reason whereof every man determined either to conquer or to die in the field. This deadly battle and bloody conflict continued ten hours in doubtful victory, the one part sometime flowing and sometime ebbing; but, in conclusion, King Edward so courageously comforted his men, refreshing the

weary and helping the wounded, that the other part was
discomfited and overcome, and, like men amazed, fled
toward Tadcaster bridge, to save themselves. . . . This

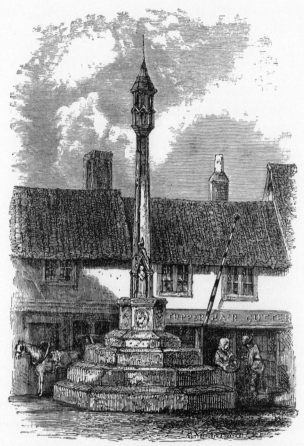

Newark Cross.

conflict was in manner unnatural, for in it the son fought
against the father, the brother against the brother, the
nephew against the uncle, and the tenant against his

lord." Above thirty-six thousand men are computed to have fallen in the battle and pursuit.

Shakespere, in the Third Part of *King Henry VI.*, describes with his usual felicity the distressing features of this great civil conflict. There is a son who had killed his father without knowing him :—

> "From London by the King was I press'd forth ;
> My father, being the Earl of Warwick's man,
> Came on the part of York, press'd by his master ;
> And I, who at his hands received my life,
> Have by my hands of life bereaved him."

And then there follows the scene of a son killed in like way by his father, who says—

> "What stratagems, how fell, how butcherly,
> Erroneous, mutinous, and unnatural,
> This deadly quarrel daily doth beget !—
> O boy, thy father gave thee life too soon,
> And hath bereft thee of thy life too late !"

Newark, by the old roads, would be about seventy-three miles from Towton, and here the body of Beaumont was brought for interment, and the cross of which we are writing was erected by his widow to his memory. It is a valuable example of a memorial cross, as the date is so completely fixed; and, singularly enough, at Wakefield there is a most beautiful chapel, built on the bridge over the Calder, to commemorate those who fell on the other side of the combatants. The canopy of this cross has been restored in recent times ; in all probability it was tabernacle-work originally. In an engraving, apparently about ninety years old, the present canopy is not given.

The Cross of Headington, in Oxfordshire, is a fine old specimen of fourteenth-century work. To some extent it

bears a resemblance to Newark ; but it has the advantage
of a fine base, composed of quarter-foils, which enclose a
kind of open book in the middle.

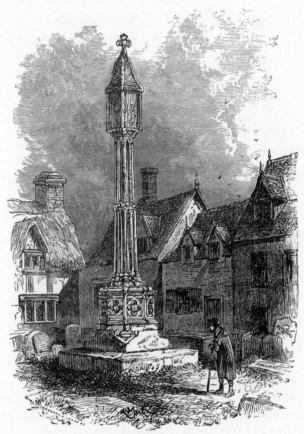

Headington Cross, Oxford.

King Edward the Confessor was born at Islip, near here,
and for some time he lived at Headington. The palace
of his father Ethelred was in the neighbourhood : its
site is believed to be in the grounds of a house called

the Rookery, in the vicinity. The date of Headington Cross is uncertain; but it is indisputable that in the fifteenth century the kings of England had a chapel in the

Head of Henley Cross.

royal manor of Headington, and equally certain that the cross was standing then. The head of the cross is modern, and simply a kind of rude tabernacle-work. It belongs to the same class of heads as that of Henley, in Warwickshire, which was probably a 'contemporaneous structure, and another at Delamere, which has only recently been exhumed.

The head of Henley Cross is here given; it is very curious. There is a most singular carving of the crucifixion overshadowed entirely, as it would seem, by the Supreme Being in the act of benediction. Perhaps there is nothing like this in England, nor can we recollect any similar ancient device in any other country. This head is borne up by four angels at the angles, which seem never to have been surmounted by pinnacles.

There is a very remarkable cross at Leighton, near Bedford, commonly called Leighton-Buzzard. The affix

of Buzzard has been considered an abbreviation of "Beau-
desart." This, we think, is a mistake. In old documents
it is spelt Bosard and Bozard. There was an old family

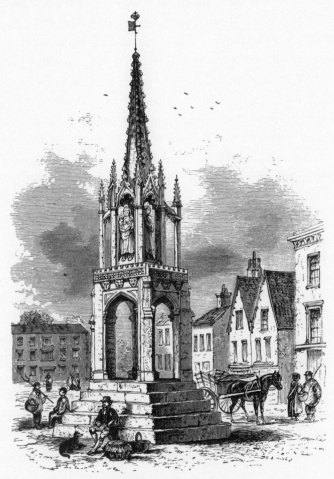

Leighton-Buzzard Cross, Bedfordshire.

of that name in the reign of Edward I., and they appear
again in Edward III.'s time, as knights of the shire.

This cross would seem to date back to the reign of Henry VI., so far as its mouldings and general character may be taken as an indication. It is pentagonal in plan, is twenty-seven feet high, on a base of five steps, with pinnacles, fifteen heads, and niched figures; there is a strong central column. It was restored in 1650. Notwithstanding all we can say in praise of the unerring skill of mediæval designers, any form of uneven sides is not satisfactory; as we have before remarked, it must of necessity throw one side out of the centre in nearly any position from which it may be seen; this defect is very much more noticeable in the otherwise éxquisite cross of Geddington, one of the Eleanor crosses illustrated in a previous chapter.

Leighton-Buzzard Cross appears to have been originally designed for three stories, though there is no evidence that it ever was carried out according to this plan. The abrupt termination is very striking, giving the structûre a heavy and ungraceful appearance. If another stage be added, the improvement will be plainly seen.

The once celebrated Cross of Abingdon, in Berkshire, was built by the brethren of Holyrood Cross, who were a fraternity belonging to the Abbey of Abingdon. Among the governing body were Sir John Golafre and Thomas Chaucer, the son of the poet; the latter, it is generally thought, was concerned in designing Abingdon Cross. It has been described by Leland as " a right goodly cross of stone, with faire degrees and imagerie," situated in the market-place. This cross was repaired in the year 1605 by the gentry of the neighbourhood; and an incident like this shows that, notwithstanding the sudden reception of

a foreign style, a real admiration of genuine English architecture was not by any means extinct. One gentleman subscribed the sum of £30, a large amount in those

Abingdon Cross.

days for any such purpose. At the treaty with the Scots in 1641, a gathering of two thousand people sang the 106th Psalm at the cross. It was a curious circumstance

that they should select that place for this particular ceremony, as all crosses were proclaimed idolatrous by their preachers. Already many grand old monuments had been senselessly swept away; Abingdon Abbey was destroyed a century before, as were many of its fellows; glorious relics of architecture were heaps of stones, which from that day even to this have served to build barns and granaries. Time has now transformed many a demolished building into a pleasing ruin; then, however, the breaches were recent, and the remains uncovered with moss. But these things did not move them. The intolerant fury against what were called superstitious edifices, which has destroyed so many beautiful monuments of art both in England and Scotland, decreed the destruction of Abingdon Cross, and it was "sawn" down by Waller's army in 1644. Even Richard Symonds, an officer in the Cromwellian army, paid a tribute to its beauty.

Coventry Cross was built, it is believed, after the same design as Abingdon; and though the former is also destroyed, we are in possession of abundant documents and drawings to show what it was like. It is later in style than Waltham, and much more florid. Perhaps, indeed, it cannot fairly, considering its date, be compared with that incomparable work of art; but it must have been very grand when complete. Britton, in the "Antiquities of English Cities," gives a most interesting account of it. It was so richly gilded, that we are assured when country people came to Coventry, they could "hardly bear to look upon it when the sun was shining." The history of this cross is somewhat curious. It was built at the cost of Sir William Hollis, who made a bequest for that purpose,

himself laying the first stone. It was erected on the site of an ancient cross, of which we have been unable to find any record or description. The town leet of that time were duly sensible of its worth, for they passed laws to protect it from injury. Among these was a fine of three shillings and fourpence for sweeping dust in the enclosure —the cross-cheepinge as it is called—without previously sprinkling the dust with water to prevent its rising upon the gilded work of the cross.

The regilding of this magnificent structure, in the year 1668, used up, we are informed, 15,403 books of gold. It is quite an unsettled question how far this mode of decoration in the open air is consistent with High Art. It is true the Greeks used it to a very great extent, and the Acropolis was at one time a vast mass of coloured marble buildings. Great allowance must be made for the climate ; it is well known that steamers plying between the Mediterranean ports and England soon find a difference in the polish of the brass fittings, for there they remain bright for many days, while in Liverpool or London they become dim, if polished ever so carefully, after being for a few hours in either harbour.

The cost of repairing and regilding the cross in 1668 was the large sum of £276 2s. 1d., and the articles are yet in existence which confirm the agreement. The Mayor of Coventry, in his official capacity, seems to have made the bargain for the restoration with one John Sweyne, who resided at Brereton, in Cheshire, and his avocation seems to have been "stone-cutting." It seems almost incredible that the beauty of this cross should not have preserved it from deliberate destruction even so lately as the close

of the last century. It was considered by the sapient inhabitants to be behind the age, and rather in the way!

Some features of Coventry Cross are very curious; fortunately it is preserved in an excellent copper-plate engraving, now not procurable, published by T. Deago, of

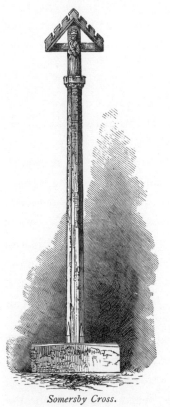

Somersby Cross.

High Street, St. Giles's. There were a vast number of figures on it; at the summit was a statue of Justice with scales, and on the opposite side one of Justice with a sword. Slightly above these was a figure of Mercy with an extended arm. The total height of the cross was nearly sixty feet.

The last cross we shall allude to in this chapter is Somersby, near Horncastle, in Lincolnshire, which is widely different in appearance from any we have as yet considered, and, indeed, is quite unique in England. It is fifteen feet in height, is surmounted by a triangle, embattled, and the top of the shaft has an embattled head. In other respects it is a tall, graceful column, octagonal, and springing from brooches which rest on a square pedestal. On one side is a figure of the Virgin and Child, and on the other is the Crucifixion.

This cross is pleasantly situated in the churchyard of Somersby, on the south side of the church. Whether it is a memorial or a weeping-cross there is nothing to determine; nor, indeed, can we discover the date of its erection; it may have been about 1450, judging from its general character. The church presents few points of interest architecturally : the living has long been in the gift of the Burton family, whe are lords of the manor.

VII.

THERE are many crosses yet standing in England that date back far beyond the Conquest, and far beyond any ecclesiastical buildings, even among those that are in ruins. These ancient relics are most curious and instructive, reminding us how little we know of Britain from the time the Romans left it to the time when, under the iron sway of William of Normandy, it was consolidated into the kingdom it has remained to the present day. There is a long hiatus from the Roman period to the early dawn of recorded history over which all the chronicles we possess cast but an uncertain light.

In the year 398 Stilicho sent effectual aid to the Roman colonists in Britain, who felt the loss of the legions that were recalled for the defence of the capital; and for awhile they were protected against the savages of the Grampians. and the adventurers from the Elbe and the Baltic. It seems strange, when we contemplate such vast Roman remains—splendid cities, villas, and roads which were not equalled until Telford's time—that the colonists could do so little to protect themselves against rude tribes. Honorius tried to arouse them, but he tried in vain; and after sending them aid A.D. 422, he left them to their fate.

Among the emigrants that continually came from Rome were not a few Christian converts. St. Ninian arrived as early as about the year 350, and founded a monastery in Galloway. Many others followed, and St. Columba, who was born in Ireland in 521, landed about two centuries after St. Ninian in the desolate dominion of the Picts, and with twelve friends founded the monastic retreat of Iona. Now, as missionaries were sent out from these homes of Christianity, it is easy to comprehend how forms of ancient crosses may have been transported to various parts of England ; yet so far we have not been successful in finding the dates of the oldest of them.

There is a singular resemblance between the architecture of these crosses and other remains of antiquity of which history leaves us in the dark. The Runic sculptures have a strikingly Eastern appearance. It may, of course, be quite accidental, but it is a singular circumstance that the ancient rites described by Stephens in his "Ruins of Central America," and well delineated by him—those mysterious and vast cities round which hard wood forest-trees have grown, and quietly thrust up stones weighing many tons—seem to have travelled round the globe by the East. This ancient architecture appears in China, and on some Pacific Islands long deserted ; it is strongly developed in Hindostan among the ancient ruins, and there are many traces of it in the older cities of Italy, which had arrived at a high state of civilisation long before Rome was built. The coincidence of design is curious, but the cross at Carew, or the Runic stone at West Kirby, might easily pass for stones from the very farthest East.

The "old crosses" at Sandbach, in Cheshire, have long

been considered to be the most interesting and ancient
Christian relics in England. Sandbach is situated in a

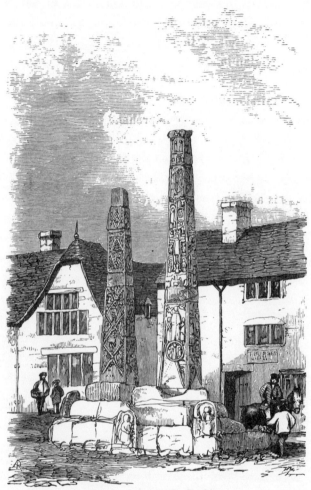

Crosses at Sundbach, Cheshire.

rather uninteresting part of the county, though there are
some excellent specimens of antique architecture in the

neighbourhood; among which are Crewe Hall, and the old hall at Sandbach, now used as an hotel and as an office for Lord Crewe's agents.

An excellent account of these crosses has been written by Lysons and Ormerod. It is supposed that they were raised on the spot where a priest from Northumberland first preached Christianity, and that they were erected in the eighth century. Startling as this date may seem, there appears little reason to doubt its accuracy. The stone they are cut from is the very hardest of the lower Silurian formation, and seems almost to defy abrasion.

On the lower part of the east side of the higher cross is a circle (shown in the engraving), containing what in all probability has been correctly called the Salutation of Elisabeth; the figure in the centre is supposed to be from Luke, "The power of the Highest shall overshadow thee." Above this circle is the "Annunciation," "Behold from henceforth all generations shall call me blessed." Above this is a sculpture of the Crucifixion; at the foot of the cross are the figures of Mary, wife of Cleophas, and Mary Magdalene; while in singular grotesque series are the emblems of the Four Evangelists: these are just indicated round the intersection of the cross—that is to say, an angel is cut for St. Matthew, a lion for St. Mark, a bull for St. Luke, and an eagle for St. John.

There is much precision about the sculptures, and an infinite amount of action, as in the bringing of Christ into the judgment-hall, Pilate seated on the judgment-seat, and the contrition of Judas—it will be remembered that Judas repented of his treachery, and cast down the thirty pieces of silver in the Temple, and he is here represented with his

head depressed, as showing his remorse; above this, over the plain blank stone, are certain figures that are said to represent the "implements of the passion," such as hammer, pincers, &c.; but this sculpture is much mutilated.

A local description of these singular medallions, which is at least careful, says :—"On the west side of the cross is a plain cross; in the lower quarters are two dread, fiend-like animals, in the act of biting the transverse part of it; their tails are fretted, gnawed, and terminated with a snake's head." This is obviously the seed of the woman bruising the head of the serpent. Higher up is a rude representation of the angel Gabriel appearing to Zacharias in the Temple, who is seated on a chair, struck dumb. Quoting the local description above alluded to, "Above is a man walking with a club in his hand, and followed by Simon the Cyrenian, carrying over his shoulder the cross." Of course this may be the correct interpretation, but in such rude sculpture there is much that is merely conjectural. As there are two unmistakable stars in each panel, it would perhaps be more consistent to consider them as the Magi: "We have seen his star in the East, and are come to worship him." This would be more consecutive as to time, for the panel immediately above is said, and perhaps correctly, to be the bringing of Christ bound before the judgment-seat.

Another side is filled with beautiful filigree-work, not at all inconsistent with the late Colonel Forde's theory of the still greater antiquity of the crosses than that already suggested. He attributes the date of their erection to the seventh century of the Christian era. It was owing to him that the fragments were collected and restored as far

as they have been; he was Lord of the Manor of Sand-
bach, and a very accomplished antiquary. It is a very
singular circumstance that on a cross at Kells, in Ireland,
the sculptures of which resemble those on the large cross
at Sandbach, there are undoubted Roman knights and
horses, and a very perfect centaur, with a bow in his hand.

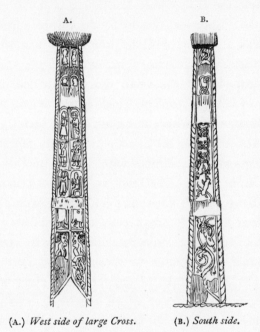

(A.) *West side of large Cross.* (B.) *South side.*

The crosses in Ireland, it is needless to remark, are very
much more ancient than those in England.

On the north side of the large cross are a succession of
figures one over the other, and this is said to represent the
" descent of the Holy Ghost, in the shape of cloven
tongues, to the Apostles; they are placed in narrow cells,
in a double row from the bottom: it is remarkable to

observe that the division on which each stands is cut off at one hand, so as not to touch the sides, leaving an uninterrupted communication between the whole, which is not observable in other parts." This very peculiarity, however, would almost seem to indicate a " Jesse tree," an ancient and favourite emblem, and the sculptures would then represent the Holy Ghost descendiug in the form of a dove, and the " Apostles " would be the row of ancestors, " Which was the son of Heli, which was the son of Matthat, which was the son of Levi," &c., &c.

"The north side of the small cross is divided into a double row of cells, in each of which is a man, all in the act of walking, some with short daggers in their hands, others without, which in all human probability represents Peda setting out from Mercia with all his nobility and attendants from Northumberland to solicit the hand of Alchfleda, King Oswy's daughter; and on the west side is a triple row of figures in small cells, and a tableau which is supposed to represent Peda receiving baptism. On the south side are like figures to those on the north, all travelling on; but instead of daggers, they carry staves in their hands. The version which the local description gives of these being Peda and his attendants is most probably correct, for Peda was the son of Penda, the King of Mercia, who was always at war with the neighbouring princes. He was deputed governor of the Middle Angles, and arrived on a visit to Oswy, the King of Northumbria, who had embraced Christianity, and sought the hand of his daughter Alchfleda, for whom the pagan young prince had conceived a great passion. He was allowed to marry her on condition of his embracing the Christian faith.

This he consents to, and returns with his bride and some priests to his own court, promising that the priests should have every opportunity of preaching the Christian religion."

The east side of the small cross is exceedingly curious, and it is doubtful if any ingenuity of interpretation could make anything out of it; the events or circumstances to which it alludes are, in all probability, not recorded in history. There are five lozenge-like compartments, though originally there were more, and the interstices are filled with figures of men and animals; in the uppermost lozenge is the figure of a bull, with his head reflected on his back. In the top part of the next lozenge is the figure of a man, with his hands stuck in his sides, and his feet extended from one side of the lozenge to another. In the base are two men endorsed. The next is partly mutilated, but seems to have been filled in with something of the reptile kind; and in the next two are men with clubs in their hands. The whole of the subjects on this side are enclosed in a curious fretted margin, laced and indented, but of exquisite design and workmanship.

It is uncertain when these crosses were mutilated, but great violence has been necessary to pull them down, for the large cross in its fall has torn away a great part of the socket-stone in which it had been firmly fixed, on the opposite side from that on which it fell; the bottom part was split with wedges, and long served to protect the sides of a neighbouring well, while other fragments of this truly interesting relic were used as doorsteps and guards for the corners of walls : some parts were taken to Oulton Park, the seat of Sir Philip de Malpas Egerton, where

they served to adorn a grotto. The restoration of these relics was entrusted to Mr. Palmer, of Manchester, and he had the valuable assistance of Mr. Ormerod, of Sedbury Park, the author of the " History of Cheshire."

It may be remarked that the whole of the groups in the larger cross are from Scriptural subjects, while those in

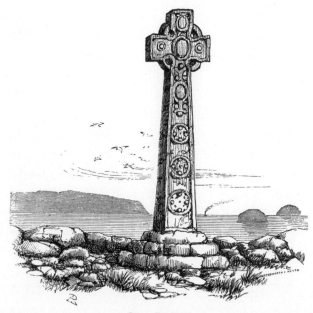

Iona, Scotland.

the smaller one relate most probably to secular history, much of which must for ever remain unknown, as in all probability the events portrayed in the panels are not preserved in any history, and these rude old sculptures are the only record left. They were originally terminated by a form of cross and circle, similar to those in Scotland or in Ireland, but these have long been destroyed: never-

theless they are most interesting and well-preserved relics
of antiquity.

Much similarity of character will be observed between

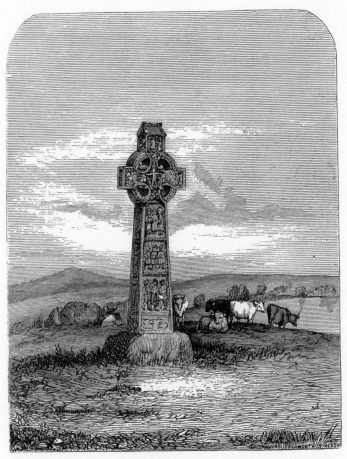

Monasterboice, Louth.

the crosses of Sandbach and those of Iona, in Scotland,
and Monasterboice, in the county of Louth, both of which

are here shown for the sake of comparison. When Boswell and Johnson visited the ruins of Iona, the former was much disappointed with the rude remains,—having pictured to himself sculptures hardly, if at all, inferior to those of Westminster Abbey,—and expressed his surprise to his companion, who made the well-known rejoinder: "We are treading now the illustrious island which was once the luminary of the Caledonian regions, whence

Incised Slabs, Chester Cathedral.

savage clans and roving barbarians first derived the blessings of religion. Whatever withdraws us from the power of our senses, whatever makes the past, the distant, or the future predominate over the present, advances us in the dignity of thinking beings."

The monastery of Iona was at one time a splendid seat of learning, whence priests were sent out into all parts of the world, and where in their pilgrimages they met with

brethren from the south on their travels to the north; and thus, while a distinctive character is maintained in the crosses they caused to be erected, there is yet a similarity,

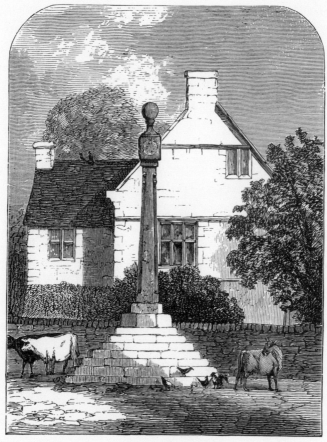

Bromboro Cross.

and in some there is a nondescript character (if indeed such a word can be applied to any one branch of their quaint architecture beyond any other part) that would

almost seem to point to the joint design of northern and southern monks.

Sculptured crosses, and sometimes incised slabs, were placed over the graves of ecclesiastics from very ancient times, and two recent ones, probably about A.D. 1350, which have been brought to light in the restoration of Chester Cathedral, are shown on page 92.

At one time it is said a Runic cross stood in the village of Bromboro, in the hundred of Wirral, in Cheshire; but the only cross that is now standing was built about the year 1400. It is in a very pleasant English-looking village, on the high road between Liverpool and Chester. One remarkable feature in it is the high flight of steps, all of which have very small treads. The upper portion of the cross has been taken away, and a very unsightly sundial substituted, with a large round ball over it. It is in good repair, and might be restored to something like its original form without great expense.

VIII.

T was not possible to conclude the more ancient forms of crosses in one chapter; indeed, they might be continued almost indefinitely, for in Cornwall, and some parts of Devon and Wales, they are very numerous. The Sandbach crosses seem at first to be curious isolated memorials, and they are all the more interesting from there being so very little that resembles them in that part of England; on this account some very curious Runic crosses which have been discovered at West Kirby are worthy of note. True it is, this place is forty miles away, but in the same county. The class of sculpture, though common in Scotland and Ireland, and not unknown in the Isle of Man, is rare in England, as has already been noticed. It would seem not to be without connecting links, however, for opposite to the West Kirby Cross was Hilbre Island, at the mouth of the Dee, easily approached at low water over the celebrated Dee Sands, that have so often proved fatal to wayfarers when overtaken by the rising tide. On this island, which is now only inhabited by a lighthouse-keeper, there was at one time a cell of Cistercian monks in connection with Chester Cathedral; traces of it have been recently discovered. A red sandstone cross of

Eastern character, with a ribbon moulding, was found here; it appears to be a little later than the one at West Kirby. Mr. Eckroyd Smith, speaking of it, says: "The cross is similar in design to several found in Ireland and the Isle of Man, except in its circular border, which closely resembles the Greek *meandros*, and is of rare occurrence, as we have only been able to discover it, but associated with other details, upon the following crosses, all situate in the Isle of Man, viz., Ballaugh Churchyard, with Runes; Kirkandrew's Green, at the church gates; garden of the vicarage, Jurby." A sepulchral stone, evidently of a date anterior to the Norman Conquest, was found on the island, in what was certainly at one time a graveyard; the style corresponds very materially with the cross above described.

The parish of West Kirby is situated in the north-west part of Cheshire, and contained two churches—one the parish-church, and the other a chapel of ease upon St. Hildeburgh's Eye, as it is called in old documents; singularly enough, all mention of it is omitted in Domesday Book; indeed, our information of it is derived from the charters of St. Werburgh, in Chester, and it is from this source that Ormerod principally quotes.

The remains of the Runic cross here engraved were found on the banks of the estuary of the Dee, and were only disembedded recently, during some repairs to the venerable church. The two fragments formed part of the shaft. Mr Eckroyd Smith, speaking of this relic, says: "It belongs to a class of sculptured remains which, though of not unfrequent occurrence in Scotland and Ireland, are rare in England. Upon each of the four sides, complete

or fragmentary, appears a Runic knot or braid; two of
them are so badly chipped that the ornament is hardly
recognisable, but their fellows display varieties of the
Runic interlacing work of great variety." In Dr. Stuart's
excellent book on the "Early Sculptured Stones of
Scotland and the North of England," there does not
appear to be any stone presenting the varieties of those
given here.

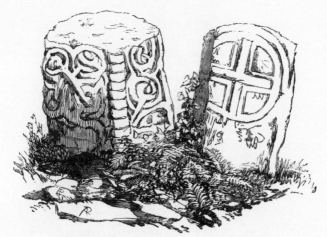

Remains of Runic Cross, West Kirby, Cheshire.

It is not a little singular that in the immediate vicinity
of this cross was found a magnesian limestone lintel five
and a half feet in length, and sculptured with the same
kind of interlaced work as the Christian relic; there is
hardly a doubt that these two interesting remains belonged
to some old temple of which all record has long since
perished.

The late Mr. Gilbert French wrote an elaborate article
to show that these twisted Runic designs were simply the

attempt to imitate in stone the osier-work of our Scandi-
navian ancestry; but the reasoning is perhaps hardly
cogent, though the theory is now commonly adopted. It
will be remarked that the angles of these stones are *corded,*
which is uncommon in contemporary remains.

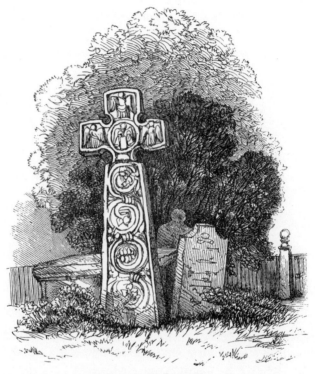

Eyam Cross, Derbyshire.

The next example we shall notice is that at Eyam, in
Derbyshire, which is an old Saxon cross of excellent pro-
portions, situated in the graveyard of the parish church.
It is in a good state of preservation, and, like that of
Bakewell, is a very perfect example of the period in which

it was built. There are five elegant scrolls cut upon the
front of the shaft in relief, and in the middle of these is a
trefoiled leaf. A slender spray also is cut over the volute,
terminating in a similar trefoiled leafwork. The curves
of the foliage bear some resemblance to Roman work, and
whatever may be the date, there is no doubt they have
been copied from Roman scrolls.

Eyam is a village on the Peak, not very far from
Bakewell; and in 1757, in digging a grave near the fine
old cross, three out of five men were struck with a remark
able illness, closely resembling the plague of 1666, and
died. The fact led to curious speculation, for this village
was attacked by the plague, which was supposed to have
been brought from London in a box of clothes. Mompes-
son, the rector of the parish, devoted himself with great
courage to stay its progress. He lies buried only a few
feet from the cross. This interesting relic lay in pieces in
a corner of the churchyard when John Howard, the phi-
lanthropist, had it restored to its present site.

Bakewell Cross strongly resembles Eyam, but the scroll-
work is not so graceful; it is also in the churchyard, and
is much more ancient than the church, though the latter
contains some fine Norman work. The town of Bakewell
is delightfully situated in the vale between Matlock and
Buxton, and its other attractions overshadow the cross.

Carew Cross, which is situated in a remarkably pic-
turesque part of Pembroke, differs very materially from
either of the above-mentioned, and more closely resembles
the Eastern relics we have spoken of. The interlaced
work is identical with many examples in Ireland, Scot-
land, and the Isle of Man; its exact counterpart may be

found in old specimens of metal-work, or carvings from Cairo or Rosetta, also in the interesting ruins of Central America. This cross stands about fourteen feet high, and is a monolith. There are characters upon it which have not hitherto been deciphered.

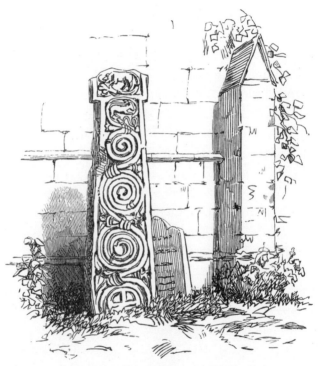

Cross in Bakewell Churchyard (East Side).

Carew Cross greatly resembles the cross in Nevern churchyard, and indeed all the remarks upon the former would apply to the latter, which forms the subject of a woodcut. The upper part of the Nevern cross might easily be mistaken for Chinese or Hindostan work, and the lower

consists of the interlacing common to many half-civilised nations. The date of these two crosses is uncertain.

The crosses in Cornwall are formed of granite or serpentine—trappean rocks that seem to have been formed out of

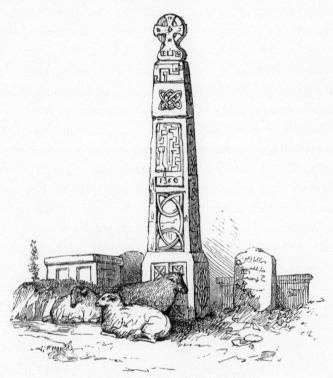

Cross in Nevern Churchyard, Pembroke.

the *débris* of volcanoes, such as dust and ashes. Most of these rocks are formed under water, are exceedingly hard, and in consequence but little changed.

The Cornish Britons remained separate from the Saxons down to the time of the Norman conquest, when their

lands were appropriated by the Norman chiefs, though their monuments remained almost undisturbed.

Hugh de Poyens, the first superior of the Knights Templars, visited England, A.D. 1128, and many grants of land were made to that fraternity in the county of Cornwall. At the breaking out of the Crusade the Pope granted the Templars the symbol of martyrdom—the blood-red cross; the Knights of St. John bore a cross of the same form, but of course black and white, and they, as well as the Templars, held lands in Cornwall, which will account probably for this particular form of cross.

Cornish crosses are very numerous; they are found by the road-sides, in churchyards, and at nearly all old cross-roads, though many have been removed. The Puritans seem to have but little troubled this part of England, and the regret is the more that there are so few architectural examples left; for this circumstance, added to the imperishable nature of the material of which they are built, would have preserved them to us. Only two examples are here given, though they might be multiplied indefinitely. One of these is the well-known Four-hole Cross, and the other is from Foraberry.

An excellent representation of Llanhorne Cross appears in Blight's "Cornish Antiquities." This is a Runic cross, and is a specimen of a small class which may be seen in a few parts of Cornwall and Devonshire.

St. Mawgan's Cross, given on p. 104, is very elaborate; and there is a legend that has not yet been satisfactorily deciphered. The tabernacle part of this cross consists of a representation of the Crucifixion on one side, and figures of saints on the others; it would almost seem to stand on

a shaft that has at some time been shortened. The base
on which it rests is evidently one of the old Cornish
pedestals. The age of this tabernacle is about five
hundred years.

In Blight's "Cornwall" there is a drawing of Llanteglos
Cross, a curious feature of which is that the enrichments
are let in with different coloured stone. This cross was

Cornish Crosses.

Four-hole Cross. *Forraberry.*

found in a trench that ran round the old church, and was
re-erected on its present site. There are two canopied
niches on the broadest sides with the usual Virgin and
Child, and also the Crucifixion; and on the narrower sides
are the figures of St. Peter and St. Paul.

Cornwall abounds with interesting, though not pic-
turesque, monuments of early Christianity. At St. Roche,
on a wild and almost inaccessible rock, is a recluse's cell

and the remains of a cross, which are very difficult indeed to reach. Such places are doubtless the cells of recluses who have made up their minds to live in spots the most difficult of access, in order to devote themselves more undisturbedly to their meditations. In some places crosses have been let into old stone walls, and are hardly to be noticed by an ordinary passer-by.

St. Mawgan's Cross, Cornwall.

To a very early period indeed belongs the cross known as Sueno Pillar, near Forres, Elgin. It is a most remarkable block of granite, of which no history is left; but it so closely resembles the stones of Nineveh that it might well be mistaken for a relic from that country. This great stone is twenty feet high and nearly four feet at the base;

and in confirmation of the conjectures which have been hazarded as to the Eastern character of this and other ancient sculptures in our land, it is curious to remark that on the top of this great pillar is the figure of an elephant. The sculptures are cut in a most singular manner: there are men and horses in military array, and in warlike attitude ; some seem to be holding up their shields in exultation, and others are joining hands in friendship, or as some token of fidelity. Then there is a fight and a massacre of the prisoners, and the dead are laid in perfect order, just as is seen on Asiatic sculptures of great antiquity. The arrangement of the men also, and of the knights, seems to be pretty conclusive that the figures do not represent any tribes that inhabited those parts at the time it was erected. On the other side of this remarkable monument is a large cross with persons apparently in authority in conference. It has been held that all this represents a scene in Scottish history, and is the expulsion from Scotland of some Scandinavians who had long infested the northern parts, about the promontory of Burghead, and had lived on "the fat of the land;" but this is hardly a tenable theory. The name Sueno which the cross bears is also said to be that of a king of Norway who made peace with Malcolm II., King of Scotland. The cross, however, denotes a Christian period, and as such we can have no hesitation in introducing it.

LIKE the common opinion that Shakspere has only been recently appreciated, and was of no account in his own times, is the idea that English architecture has only just now been valued at its proper worth. It is of no avail, apparently, that these errors are extinguished to-day, they revive to-morrow. There can be no doubt that numbers of educated men saw with dismay the destruction of crosses and other ancient monuments; so that, in fact, the real appreciation of the excellences of English art never quite died out. In Gloucestershire, Wiltshire, and Somersetshire, there are not fewer than two hundred crosses and remains of crosses. Most probably the examples given comprise all the more remarkable of them, but it is with satisfaction we see so large a number partially, at least, preserved.

A curious dialogue, written by Henry Peacham, between the crosses of Charing and Cheap, describes them as "fearing their fall in these uncertaine times," which, indeed, was only two years before the general order was issued for the destruction of crosses. There is a curious recipe for marble cement in it: Charing Cross is made to say, "I am all of white marble (which is not perceived of every one),

and so cemented with mortar made of the purest lime, Callis sand, whites of eggs, and the strongest wort, that I defy all hatchets and hammers whatsoever." Still, at the destruction of monasteries, when such glories of architecture were destroyed, it was not likely that Charing Cross, with its white marble, should escape covetous eyes : " In Henry VIII. time I was begged, and should have been degraded for that I had; then in Edward the Sixe, when Somerset House was building, I was in danger ; after that, in the reign of Queen Elizabeth, one of her footmen had like to have run away with me; but the greatest danger of all I was in, when I quaked for fear, was in the reign of King James, for I was eight times begged :— part of me was bespoken to make a kitchen chimney for a chefe constable in Shoreditch ; an inn-keeper in Holborn had bargained for as much of me as would make two troughs, one to stand under a pumpe to water his guests' horses, the other to give his swine their meate in ; the rest of my poore carcase should have been carried I know not whither to the repaire of a decayed old stone bridge (as I am told) on the top of Harrow Hill. Our royal forefather and founder, you know, King Edward the First, built our sister crosses—Lincolne, Grantham, Woborne, Northampton, Stonie Stratford, Dunstable, Saint Albans, and ourselves here in London, in the 21st year of his reigne, in the year 1289." The omission in this list of Waltham Cross, the last before the procession reached London, is curious.

The plaintive recollections of Cheapside Cross are exceedingly valuable, as they show that reverence for antiquity was strong in the time of Elizabeth ; indeed, the

intemperate zeal exhibited in destroying carved work only culminated in the century after she began to reign. Cheapside Cross is made to say :—

"After this most valuable and excellent king had built me in forme, answerable in beauty and proportion to the rest, I fell to decay, at which time John Hatherly, maior of London, having first obtained a license of King Henry the Sixt, anno 1441, I was repaired in a beautiful manner. John Fisher, a mercer, after that gave 600 marks to my new erecting or building, which was finished anno 1484; and after, in the second year of Henry the Eight, I was gilded over against the coming in of ' Charles the Fift. Emperor; and newly then gilded against the coronation of King Edward the Sixt. ; and gilded againe anno 1554, against the coronation of King Philip. Lord how often have I been presented by juries of the quest for incumberance of the street and hindring of cartes and carriages, yet I have kept my standing : I shall never forget how, upon the 21st of June, anno 1581, my lower statues were in the night pulled and rent down, as in the resurrection of Christ, the image of the Virgin Mary, Edward the Confessor, and the rest. Then arose many divisions and new sects formerly unheard of, as Martin Marprelate, *alias* Pewin, Browne, and sundry others, as the Chronicle will inform you. My crosse should have been taken quite away, and a *Piramid* erected in the place, but Queen Elizabeth (that Queen of blessed memory) commanded some of her privie councill, in her Majesties name, to write unto Sir Nicholas Morely, then maior, to have me again repaired with a crosse : yet for all this I stood bare for a yeare or two after. Her Highness being very angry,

sent expresse worde she would not endure their contemp, but expressly commanded the cross to be set up, and sent a strict command to Sir William Rider, Lord Maior, and bade him *respect my antiquity*," &c.

The above is a graphic, and no doubt very accurate, description of the treatment of ancient monuments in the past without iconoclastic decrees. At the present time, even, venerable half-timbered structures are remorselessly demolished to make way for new premises. It seems very disgraceful that buildings which have stood for centuries, and are still in good condition, should be sacrificed to so-called modern improvements. In most instances they might be adapted, without much difficulty, to the mercantile exigences of the times ; at any rate, space might be found without destroying the now-diminishing number of ancient remains. There can be no doubt that the discussion of this subject will assist the hands of the Government Commission appointed to protect monumental antiquities, and possibly enable them to embrace a wider range in their excellent work.

Cheddar is situated in a deep gorge on the Mendip hills, and is not surpassed in beauty of situation by any village in England. The "Parliamentary Gazetteer" thus describes it :—" The ravine is narrow, and the cliffs on each side ascend abruptly to the height of many hundred feet. Some portions of the Cheddar cliffs remind one of a lofty Gothic structure, the action of the elements having worn the rock into niches and columns ; and the lofty summits of stone, without much exercise of imagination, seem to assume the appearance of turrets and spires. Immense numbers of jackdaws are constantly flying about the

middle and upper sections of the cliffs; hawks too of
various kinds make their aeries in these rocky fastnesses;
and the visitor to this sublime scenery may constantly
witness them sailing on steady wing in mid-air in all the

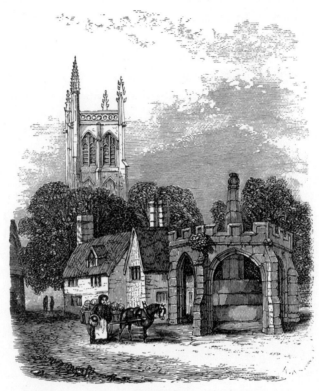

Cheddar Cross.

security of an uninhabited region." The church, shown
in the engraving, is supposed to have been built about
1400, and has a sculptured stone pulpit. The cross is a
curious instance of altered design.

It will be noticed, on reference to the plan, that it was

at first intended to build a hexagonal structure, and the steps are cut in that form; but on arriving at the top one, from which the cross springs, the designer fitted in an octagon base, and that too not perhaps in a very artistic manner. The general appearance of the cross, however, is picturesque, though it has no architectural attractions to recommend it. Formerly it was simply a village high-

Plan of Cheddar Cross.

cross, like many others; it is on record that it was surmounted with a large tabernacle, in which were figures.

Round Cheddar Cross a heavy stone canopy has been built, apparently in the reign of Henry VIII. A curious feature in this addition is its scantiness, for there is only one foot between the piers of the canopy and the steps of the cross. The smallness of the accommodation would seem to indicate that it must have been a preaching-cross,

for not a dozen market-baskets could find shelter beneath it. From its steps on summer evenings, notwithstanding its proximity to the church, the preacher would doubtless frequently address a congregation and lead the hymn. The cross stands at the junction of three roads, at the entrance to the village. With every desire to appreciate the merits of ancient design, one is compelled to admit that the structure is more interesting and curious than beautiful. Britton thus speaks of it in his somewhat rare work on the " Antiquities of England :"—

" This shattered cross at Cheddar seems to have been constructed at two different periods, as the central column constitutes one of those crosses that had merely a single shaft raised on steps. The lateral piers, with the roof, were probably erected at a later period, to shelter those persons who frequented the market. Bishop Joceline obtained a charter from Henry III., 19th year of his reign, to hold a weekly market here; but this has been discontinued some years. The present cross is of a hexagonal shape, has an embattled parapet, and the upper portion is ornamented with a sort of sculptured bandage."

Although there may be something rather disappointing about Cheddar Cross when its great fame is considered, we ought to be only too grateful for its preservation. At Chipping Campden, in the northern part of Gloucestershire, is a somewhat similar structure, built apparently about the same time. It stands in a picturesque old English town, formerly of some note in the county, but now almost in decay. The word Chipping—from the Anglo-Saxon word *ceapan*, to buy—mostly indicates a place of merchandise,

which would necessarily have a market-place and cross. Chipping Campden was a great mart for wool.

The town of Shepton-Mallet is situated about twelve miles to the east of Cheddar. Wells lies between them, and is one of the most perfect examples of an ancient city in England. The Bishop's Palace is moated, with a draw-bridge, and is a fine example of an old English castellated building. Three wells overflow in the grounds and form a little lake, which is surrounded with very beautiful trees; over these rise the grey towers and pinnacles of the cathedral, built apparently in the middle of the thirteenth century; the whole being mirrored in the lake below. Perhaps there is no more impressive scene in England. Here Bishop Ken wrote the Morning and Evening Hymns·

Shepton-Mallet Cross is a remarkably fine structure, as will be seen from the engraving, and, like Cheddar, it has been built round a high-cross of earlier style. It is well situated in the market-place, and is certainly the most striking cross remaining in England, excepting perhaps Chichester, to which in some respects it is superior. It was built in the year 1505, by Walter Buckland and Agnes his wife. The original intention seems to have been to erect a high-cross, somewhat like those at Gloucester and Bristol, but it appears to have occurred that its utility might be increased by a canopy for shelter. Leading from the market-place is a narrow street, with substantial houses and shops, which opens up a fine view of the Mendip Hills. Many celebrated characters have been born in Shepton-Mallet, among others Simon Browne, a dis-senting minister, who wrote against Tindal, and was born in 1680. He was a man of very great learning; but some

years before his death, in 1732, he entertained and ex-
pounded the curious idea that he had no rational soul, but
was merely an unconscious atom. Perhaps his contempo-
raries have unfairly stated his views, but such they are

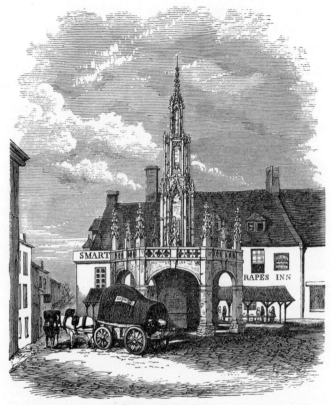

Shepton-Mallet Cross.

said to be. His memory is yet fresh in those parts, and
so also are some of his curious ideas. He never would say
grace before dinner, unless very much pressed, because
he said it was expecting a miracle.

Glastonbury is one of the few towns of England that have preserved an ancient character, even in spite of many and destructive changes; like Malmesbury, the grand old monastic buildings have quite incorporated themselves in the houses of the town, and, happily, much of the old monastic architecture remains. Here, as tradition tells us, Joseph of Arimathea rested on his way to preach the gospel to the British, and while wearied in his ascent of the hill he drove his staff into the ground, which is said to have taken root and ever since to blossom at Christmas time—at least, so say the guide-books. It is beyond doubt that a very fine old thorn does grow there, and probably it blooms early, which, from my own knowledge, is all I can affirm.

Glastonbury Old Cross was a quaint, though perhaps not very pleasing structure. Until a comparatively recent date it was in a good state of preservation, and harmonised extremely well with its surroundings. The whole town is a series of old associations, and it may not be out of place to quote a description of it from the pen of a local antiquary:—" We have hardly left behind us the flats that surround and nearly insulate the town (whence the old British name of Glassy Island), and ascend the eminence upon which it stands, before we perceive that almost every other building has either been constructed in modern times, quarried from the stone of the ruins, or is a direct remain of the architecture of the monastery from whence it is derived. The George Inn is not one of these; it preserves its old character; it was from the earliest times a house of accommodation for the pilgrims and others visiting Glastonbury."

This old cross is so curious and so singular in the
distribution of its gables that a sketch is here given.
Britton says, " Glastonbury Cross, though a large and
extremely curious structure, is hardly noticed in the topo-

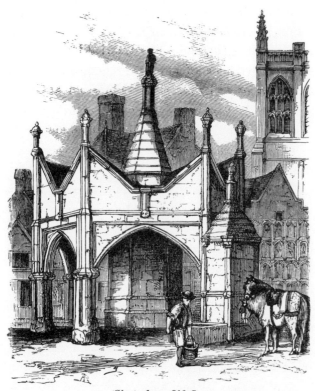

Glastonbury Old Cross.

graphic annals of this county; its history is therefore
perhaps entirely lost." Unfortunately, the building itself
also is now lost, for after Britton wrote it fell into decay
and neglect, and many stones were carried away for
modern edifices. "There is something peculiarly unique,"

he adds, "in the shape and ornaments of the building. A

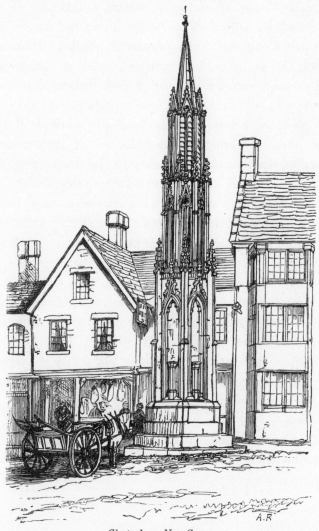

Glastonbury New Cross.

large column in the centre, running through the roof, and
terminated with a naked figure, clustered columns at each

angle, with odd capitals, bases, &c., and pinnacles of
unusual shape, all unite to constitute this one of the
eccentricities of ancient building. From the time of the
Norman Conquest to the dissolution of English monas-
teries, the varied and progressive styles of architecture
are satisfactorily defined, and a very general uniformity
prevails in all the buildings of a particular period; but
the specimen before us differs from any example I ever
met with. Hearne, in his 'History of Glastonbury,'
Camden, Willis, and Stevens, are all silent regarding this
building." There was a mutilated inscription, dated 1604,
upon it, and also a shield with the arms of Richard Beere,
the last abbot but one, who died in 1524; it would almost
seem that an inveterate spirit of punning had even reached
the sacred precincts of the armorial bearings, for, in
allusion to his name, as would seem, there are two cups
with a cross between. There was a conduit at one corner
with a trough, and this added greatly to the picturesque-
ness of the scene.

The present Glastonbury Cross is not unlike the copy of
the ancient Bristol high-cross at Stour Head, or the de-
molished one at Gloucester, both of which will form the
subjects of the next chapter. Statues are wanting to
complete the outline, but the structure is pleasing, and it
is well situated.

X.

THE history of Bristol high-cross is interesting and somewhat sad. It was built in 1373, according to some accounts, and according to others in 1247. A passage in a MS. calendar thus refers to it :—" Anno 1247. Now that the bridges went happily forward, the townsmen on this side of Avon and those of Redcliffe were incorporated, and became one town, which before was two, and the two places of market brought to one, viz., that at Redcliffe side being kept at Temple Cross, or Stallege Cross, and also that from the old market near Lawford's Gate, both being made one, were kept where now it is, and a faire cross there built, viz., the High Cross, which is beautiful with the statues of several of our kings." Mr. Poole, in an excellent little work on Bristol Cross, says : " It is difficult to account for this discrepancy of dates otherwise than by supposing that either the calendars are not trustworthy records (and the fact that the pen of Chatterton was known to touch some of them renders their unqualified acceptance as historical documents anything but easy), or else the rebuilding of the cross in 1373 consisted in certain additions and embellishments, the rest of the high cross, with the statues of the kings, remaining as it was before·" One thing, how-

ever, is certain—the architecture of the present cross belongs to the period last named, and probably it was a totally new structure at that time. Originally this cross was richly coloured, the colours consisting of blue, gold, and vermilion. It was built of a coarse-grained oolite, very liable to absorb moisture, but the polychromatic colouring preserved it for centuries. A lesson on the restoration of churches might be gathered from this fact; many fine old walls that are re-cased might be allowed to stand, if a proper colourless solution were applied to bind up the crumbling particles. It is in the nature of oolite and sandstone to disintegrate, and this process might be stopped.

Bristol Cross consisted of a series of niches with canopies of great beauty, which formerly contained statues of English kings; in 1633 the citizens raised the cross in the same style of architecture, and added the statues of three more kings and Queen Elizabeth. The cross was also enclosed in an iron railing, and repainted and gilded; but evil days were before it.

In 1733 a silversmith who lived near it made affidavit that in every high wind this old structure—which might have lasted for centuries if left alone—rocked so much that his house and his own valuable life were in danger if the cross fell towards him; so he procured its removal, and it was thrown into the Guildhall as a thing of no importance, where it lay for a long time, until Alderman Price and a few gentlemen had it re-erected on College Green, opposite the cathedral. Here it remained for some thirty years, until a Mr. Campion, a gentleman apparently of great public spirit, discovered that it stood

in the way of a walk, and opened a subscription list to
have it removed! The cross was again rudely pulled
down and thrown into a corner of the cathedral, until

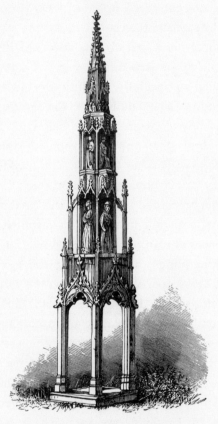

Bristol Cross.

Dean Barton gave it to Sir Richard Colt Hoare, who
erected it most appreciatively in his park at Stour Head.

Bristol New Cross is a copy of the old one, excepting
that the upper part is divested of the Carolian ornaments,

which gives it an incongruous appearance; the canopy
also seems rather too high for the rest of the structure.
The remarks of Mr. Norton, the architect, on the com-
pletion of the structure, are very sensible, in alluding to
the absence of sculptured figures. "Leaving out of the
question," he says, "the public duty to replace these
statues, I must point out to you æsthetically how pecu-
liarly unmeaning the structure now is. I know no work
of architecture so specially needing the aid of the sister
art of sculpture. The addition of the figures can alone
produce harmony of general effect; and with these, both
the architectural shell and the canopiéd statues, would
communicate to each other a borrowed aid, and thus vivify
that which is now a tame and insipid work."

We have just recorded the vicissitudes in the history of
Bristol Cross, unhappily a sadder fate awaited the sister-
cross of Gloucester: an act was passed in 1749 for taking
down some buildings, and enlarging the streets of the
city; as this cross stood on a site which the corporation of
the period desired, a decree went forth to demolish it,
and it was pulled down so lately as 1750. There is not,
as far as we could learn, any record of the uses to which
the fragments were appropriated, every trace has gone;
and yet the cross was demolished but within thirteen
years of the birth of the accomplished Lysons, to whom
antiquarians in England owe so much; it was situated
within two miles of his family-seat.

Gloucester Cross—in a note on a very excellent print by
Vertue—is said to have been erected in the reign of
Richard III., and his statue was among those demolished;
but it is probably older: the style of canopy, as far as it

can be gathered from Vertue's print, belongs to the reign
of Edward III. There were also statues of earlier kings

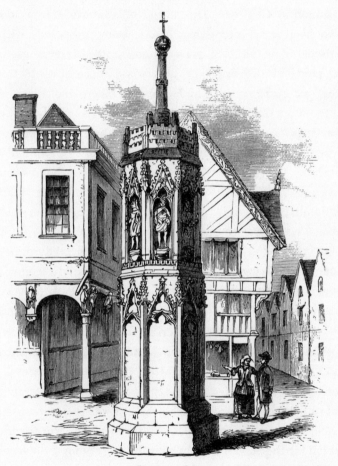

Gloucester Cross.

than Richard III., viz. John, Richard II., Henry III., and
Edward III. These figures were, as far as can be judged
from the old print, very excellent works of art, and it is

surprising that even they were not preserved. The houses round the cross were good specimens of ancient domestic architecture, and much resembled the older ones now standing in Chester. The statue of Richard III. would have been very interesting had it been preserved; and, perhaps, it would have solved some of the theories as to his physical deformity or otherwise: according to the excellent print from which this is taken, his figure is rather short than misshapen. The pedestals on which the monarchs are standing have evidently been much misrepresented in the engraving by Vertue, which is, generally speaking, a very excellent work of art; they have been drawn as though they were rough uncut stones, but in all probability they were fine old carved corbels that had become weatherworn out of all sort of recognition.

Of course the upper part of the cross is modern, not older than Charles I., and there were formerly the inevitable little flags on slight iron stems, that look so very meagre, and are seen in the prints of Coventry Cross, and others that have been restored since the Reformation. Besides the kings there were statues of Queen Eleanor and Queen Elizabeth. The latter, and that of Charles I., were probably erected in the place of some others that had fallen into decay. The height of this cross, as measured by Mr. Thomas Ricketts, to whom we are indebted for the sketch from which the engraving by Vertue is taken, was 34 feet 6 inches; but probably, or indeed certainly, there was another story, which, with the spiral termination, would have made its height some 50 feet.

From the steps of both these crosses all proclamations were read to the people. Bristol Cross was situated in

High Street, and Gloucester Cross at the junction of Southgate Street, Northgate Street, and Westgate Street.

Oakley Grove, near Cirencester, is the beautiful seat of the Earls Bathurst; the mansion is only a short distance from the town, and bears obvious marks of the architecture which prevailed during the early reign of the House of Hanover. In the park is the celebrated market cross of Cirencester, which stood in the lesser market-place. On the base is some ornamental panelling; the shaft is octangular and about 13 feet high ; round the capital were four shields of arms, now nearly obliterated. There are two steps and a fine square base to this cross. Each side of the base has four trefoiled panels, with quatrefoils over. The shaft rises abruptly from the base, and is well proportioned, though it may have been originally some-what higher.

Cirencester Cross is probably the successor of a much more ancient one, or perhaps more than one. The town itself is full of interest ; many ancient Roman statuettes have been found in subsoil ploughing in the neighbour-hood. A rather amusing story is told by Camden. In the year 1731 a fine bronze was found near the cross, and the workman who discovered it parted with it to a gentleman who was to pay according to the value he received for it : he gave the finder £20, but he himself had managed to realise £150. It was of course well sold at this sum, and the finder in receiving his £20 did probably much better than he could have otherwise done, but he looked upon himself as badly treated. The bronze was a Cupid, weigh-ing about 11 lbs.; the eyes were of silver, but the pupils were gone, and the discoverer had the ground carefully

sifted over and over again for these, as he was perfectly
sure they were diamonds; unfortunately, however, his
first treasure-trove was his last.

Cirencester is in the middle of one of the most interest-
ing parts of ˙England, and perhaps one of the most

Cirencester Cross.

beautiful; there are also remains, or at any rate traditions,
of so many splendid crosses as would now astonish us
could we only see them as they were. The wealth of
design and the beautiful forms that have been lost to us
when these relics were destroyed will never be known.
There are crosses still standing near the town, at Ashton

Keynes, Crickdale, and various other places; of some of
these engravings will hereafter be given, and some only
described.

Not far from Cirencester is Ampney Crucis; it is situated
on the Fairford road, about two miles from the town. The
cross is in the churchyard, and has some very pleasing
features. The tabernacle at the top part is more solid
than usual, and there is a kind of dog-kennel roof on a
slight curve. The shaft rises octagonally and very boldly
from two large square steps and a set-off. This was pro-
bably an example of the "weeping-cross," or place to
which penitents resorted to bemoan over their short-
comings. This is not apparently a very uncommon or
even very uncongenial pursuit with many devotees; for
up to the present day Jews go every week to the walls
of the Temple, and lament over its destruction. It is
almost impossible not to connect these weeping-crosses in
some way with old Jewish customs; there are many of
them still left in England, and the name clings to them.
One thing is certain, that the old habits of weeping and
wailing date much earlier than the destruction of the
Temple. The lamentations of Jeremiah fully attest this:—
"The ways of Zion do mourn because none come to her
solemn feasts; her priests sigh, and she is in bitterness."
Again, "Mine eye trickleth down without intermission,"
&c. "A voice of crying shall be from Horonaim, spoiling,
and great destruction. Moab is destroyed; her little ones
have caused a cry to be heard;" many other passages
occur all through the prophets in the Old Testament.
Probably more appropriate ones might be found, but these
surely express a recognition of public lamentation, and

almost an encouragement of it, that perhaps may appear strange in the present day, when the tendency of all our

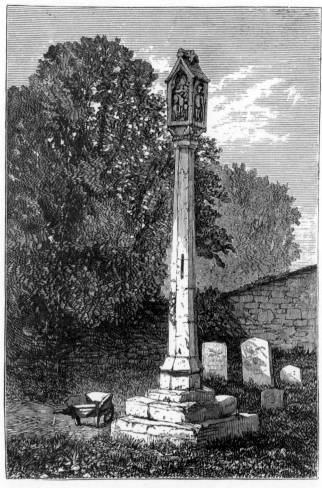

Cross at Ampney Crucis.

teaching is rather to avoid making any exhibition of strong feeling. Undoubtedly there were many crosses

connected with some demonstration; of course there were penitential crosses, where delinquents had to make a pilgrimage in a sheet in expiation of some offence. Penitential crosses were in use even in the Church of England until within the last thirty years, and that not always in obscure country villages.

The cross at Wedmore, in Somerset, is indeed, in another sense, an example of a weeping-cross. The terrible bloody assizes, as they were called, raged in these parts, and even the recollection of them would seem to be fresh in the minds of the inhabitants. It is two hundred years since they happened, yet people about there speak of them as a thing of yesterday. Jeffreys set out on what his infamous master called his "western campaign," and alluded to with such delight afterwards by that name. "Somerset, the chief seat of the rebellion, had been reserved for the last and most fearful vengeance. In this county two hundred and thirty-three prisoners were in a few days hanged, drawn, and quartered. At every spot where two roads met, on every market place, on the green of every large village which had furnished Monmouth with soldiers, ironed corpses clattered in the wind, or heads and quarters, stuck on poles, poisoned the air; and the peasantry could not assemble in the house of God without seeing the ghastly face of a neighbour grinning at them over the porch. The chief justice was all himself; his spirits rose higher and higher as the work went on." Such is the account that Macaulay gives of a circuit that will be remembered while record lasts, and that has no parallel in English history. Wedmore lies at equal distances from Wells, Cheddar, and Glastonbury, and had

furnished many soldiers to the cause of Monmouth, and to their memory this cross was erected; it was taken down from a neighbouring site and rebuilt in the pleasant old churchyard, and it still bears the name of "Jeffreys' Cross." It belongs apparently to the latter part of the fourteenth century, and is peculiarly elegant in its design, though unfortunately much dilapidated. At the top of the

Plan of Dundry Cross.

octagonal shaft are flowers peculiar to the Decorated style; the set-offs above these are curved, thus giving a light and very graceful starting-point for the tabernacle part to rise from. All the parts of this tabernacle belong to the Decorated style. The cross, when perfect, must have been very beautiful. Though the ornamentation of the Decorated style is often very rich, it is never florid; it differs from the preceding style in not being so stiff or

unnatural-looking, admirably adapted as the latter is for architectural effect ; while it is equally different from that of the Perpendicular style which followed, being more natural, and derived more generally from flowers and vegetation.

At Chew Magna there is a tolerable cross. It lies south of Bristol, on the Wells Road, and is about six miles distant. The road to it is up Dundry Hill, and at the summit of this is an octagonal cross, rising from a flight of four steps and a solid base. The date of this cross is about 1500. There are panellings of a Perpendicular character on the solid base, consisting of a four-centred flat arch divided in two by a mullion. There are crosses also at Westbury and Compton Bishop, in the same direction, only a little farther to the south ; and as for the stumps and shafts their name is legion, so numerous are they.

The crosses mentioned in this chapter are various in form, but all good examples ; there are many more in the neighbourhood, but to illustrate them would make a tedious, bulky volume of very little interest ; indeed, in investigations of this kind, one is continually doomed to disappointment ; guide-books and inhabitants are communicative enough, and ready to give every kind of information in their power, but when the goal is reached —often in journeys connected with the present work in mid-winter and in boisterous weather—the result is an old flight of steps with a single shaft, and neither ornament nor inscription.

HERE are many crosses in England which must be passed over with but slight notice. The cross at Stevington, in Bedfordshire, is not unlike the crosses at Cricklade; the stops and splays are merely repetitions of old ones. Wheston cross is very elegant, but simple in form. It has two square steps, and a solid base over them; the latter is broached into an octagon. From this rises a light and elegant cross, with a Virgin and Child at the intersection of the arms; these arms are beautifully cusped on the outside. This cross was excellently drawn by Chantrey in 1818, and engraved by Croke.

The cross at Scraptoft is curious, but much defaced; it seems to be of more ancient date, and probably belongs to the Early English period.

There was a fine old open cross in Leicester, built in the reign of Queen Mary: it was octagonal, and had a dado inside corresponding with the outer lines; an ogee roof covered it, but there was no central column. Leicester cross was pulled down in the year 1769, but an excellent engraving of it was preserved at the time. Wymondham cross seems to have been a very picturesque oak structure, with a light central column. An engraving of it is pre-

served in Bell's " Antiquities of Norfolk ;" the oak beams
were carved like an ornamental barge-board to a house ;
over it was an octagonal room, with a light high-sloping
roof.

In some very old prints of market-crosses, we find them

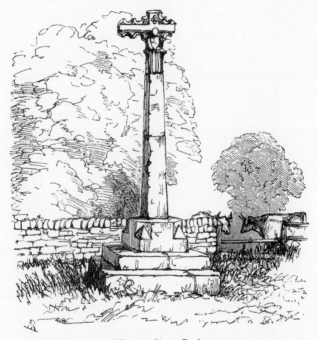

Wheston Cross, Derby.

surrounded by an enclosure about fifty feet square, built
in the form of a wall to every appearance about five feet
high, with a gateway, apparently to collect tolls ; but how
far this was general we perhaps hardly have sufficient
examples left us to determine.

At Sutton St. James parish, Holland, in Lincolnshire,

are the remains of the celebrated Ivy Cross; and at Willoughby-in-the-Wold is a good monolith fifteen feet high. At Penrith, in Cumberland, are some well-known monumental crosses, which again have hardly enough character to make them interesting subjects to delineate; and, indeed, it is only the great beauty of their situation that makes them known.

I have in my possession a good old print of a cross of which I am unable to find any record : it is a copper-plate apparently one hundred and twenty years old, and represents a structure which may be briefly described as follows : on a square base, "stopped" so as to form an octagonal top, rises a square monolith, at the top of which is a head curved outwards, and on this is a tabernacle with a Crucifixion, and some other groups on the three other sides, of which I have not succeeded so far in finding any explanation. A curious feature is that it resembles the form of the ancient cross in use at the beginning of our era, and is in the form of a T. The angles are beaded, and the beads are stopped five times over with heads and flowers. The work is old, and, so far as can be judged from the plate, is of the fourteenth century.

On the same sheet of paper is another cross, which is very curious, and perhaps unique. It stands on a round cheese-like base, which is supported on boulders; the angles are beaded, but not stopped; and there is a curious little cross cut out in relief on the front, which closely resembles a dagger. To neither of these crosses have I been able to find any clue.

In the cross at Dindar churchyard, in Somersetshire, which is here engraved, the angles of the square monolith

are beaded as in the one just mentioned, but these beads are worked in the form of small sunken angle-buttresses; there is nothing very peculiar about this cross, and it is represented chiefly to illustrate what is meant by beaded-angles. Dindar Church, which is also partially indicated,

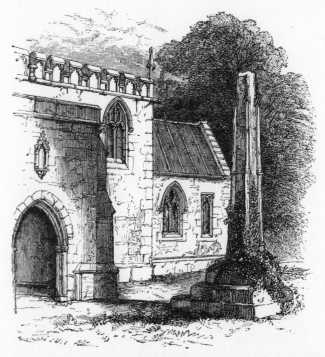

Dindar Cross.

is rather an interesting old building, and has a good Early Perpendicular porch and battlement.

Devizes is an ancient town in Wiltshire, of great historical interest, which had a noble castle built by Roger, Bishop of Salisbury, at an immense expense. He raised

himself from being a poor parish-priest to the second rank
in the kingdom ; but Stephen, bearing him a grudge

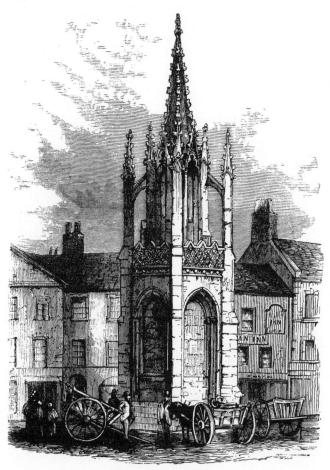

Devizes Cross, Wiltshire.

similar to that of Henry VIII. against Cardinal Wolsey,
deprived him of his great wealth, made him give up this
castle, which was second to none in the kingdom, and

reduced him again to abject poverty. The singular name of this town is said to be derived from the division of it between the Bishop of Salisbury and the king, in very early times.

The market-cross stands in the market-square, and consists of a solid base with a band of quartrefoils over, and flying buttresses at the angles. It is not perhaps very elegant in contour, but it is curious and characteristic. There is a singular inscription on it, which runs thus:—

"The Mayor and Corporation of Devizes avail themselves of the stability of this building to transmit to future times the record of an awful event which occurred in this market-place in the year 1753, hoping that such a record may serve as a salutary warning against the danger of impiously invoking the Divive vengeance, or of calling on the holy name of God to conceal the devices of falsehood and fraud.

" On Thursday, the 25th January, 1753, Ruth Pierce, of Petterne, in this county, agreed with three other women to buy a sack of wheat in the market, each paying her due proportion towards the same.

" One of these women, in collecting the several quarters of money, discovered a deficiency, and demanded of Ruth Pierce the sum which was wanting to make good the amount.

" Ruth Pierce protested that she had paid her share, and said she wished she might drop dead if she had not.

" She rashly repeated this awful wish, when, to the consternation of the surrounding multitude, she instantly fell down and expired, having the money concealed in her hand."

This cross, though very different in form, is probably contemporaneous with that at Shepton-Mallet.

The legend above given is intelligible, for many such sudden deaths under similar circumstances, where there has been great excitement, have been credibly recorded. Of course there is nothing irreverent in supposing that an inquest might have discovered some old vital complaint such as heart-disease, to be present at the time.

A celebrated cross stood in the monastery of Winchester, which was built by King Alfred for married monks. This cross spoke out openly and fervently against monks marrying: and in consequence, Dunstan, Bishop of Canterbury, turned them out, and they were superseded by others of celibate vows. There is a tradition that Canute had spent the revenues of one year of his kingdom over this cross, and worthily it seems to have requited his labours.

Eltham Cross, in the county of Kent, is broken down, though the old palace in part remains, and is one of the glories of English architecture. It was deserted at the time of the building of Greenwich, except perhaps occasionally by James I.; and during the Commonwealth, it served as a stone quarry for the erection of neighbouring buildings : indeed, it was only the accident of the hall being used as a barn that preserved it from destruction. The grand roof has been restored by Mr. Smirke, at the expense of the Government. There was a great destruction of crosses in this part of England—indeed, they have almost all been swept away.

Bitterley Cross stands in the churchyard of Bitterley, Shropshire, a village near the quaint and quiet old town of Ludlow, a town that possesses a castle which is celebrated

all over England; and is contemporaneous with Warwick, Warkworth, Alnwick, and others that figure in English history. The steep streets and black and white gabled houses, also, of Ludlow, give one—next perhaps to Chester

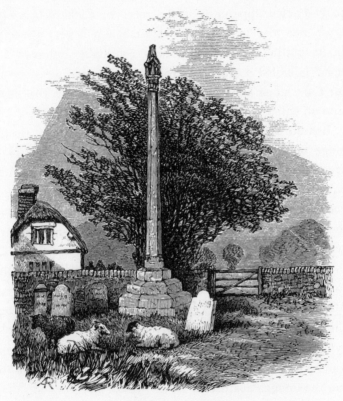

Bitterley Cross, Salop.

—the best idea we can have of a mediæval English country-town. The road to Bitterley is remarkably beautiful; there are hills on each side cultivated to the summit, while the village is literally shut in with great elms and

walnut-trees, through which gables and high twisted chimneys appear at intervals. The church is situated in the park of Bitterley Court, and the lord of the manor is the rector. There are several peculiarities about the architecture of the church, which is small, and was principally erected apparently in the reign of Richard II. The cross was also built about this time, and is very graceful in its outline; probably it was originally intended for what is called a weeping-cross. There are four steps to it; the "stops" that convert the square base of the shaft into an octagon are peculiarly beautiful and ingenious.

Behind the cross is a great yew-tree, and the abrupt ridge of the hill rises up in the background. Perhaps it would be difficult to find a better example of a tall tabernacle-cross in England. Under the representation of the Crucifixion are some light and peculiar brackets that are almost unique, and rather resemble thirteenth-century work.

There are crosses at Broughton and at Kinnerley, in the northern part of this county, and also at Great Ness, Middle Ness, and Little Ness, in the southern part; but these do not differ materially, they are built on the old type we see throughout Gloucestershire—a flight of steps and an octagonal shaft, with the tabernacle part containing the images destroyed.

Not only have crosses of all kinds been better preserved in Gloucestershire, Wiltshire, and Somersetshire, but many have been restored to their former state, either by the owners of the soil, or by the clergy assisted by the efforts of their parishoners. There are two crosses at Cricklade of great beauty of proportion. One is repre-

sented as standing in the road, where, until recently, it used to stand, though now it is removed into St. Sampson's Churchyard. This cross was apparently built at

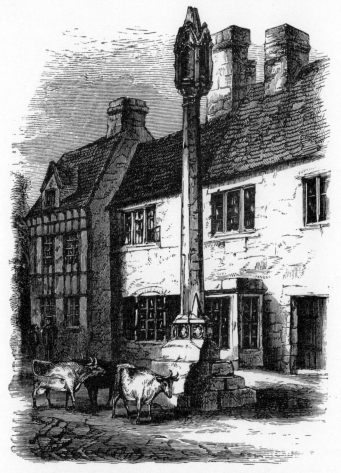

Cross at Cricklade (now in St. Sampson's Churchyard).

the close of the fourteenth century, and is certainly a pattern of lightness and beauty; of course it cannot com-

pare for a moment with the Eleanor crosses, which were
the result of profuse wealth and unlimited expenditure,
but it is a perfect model of a village-cross. Waltham
Cross, for example, could not now be built for less than

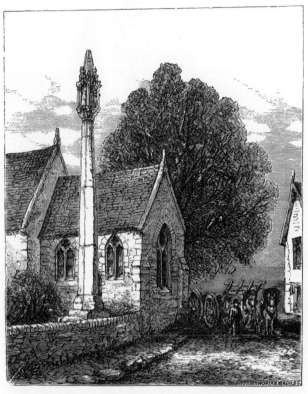

Cross at Cricklade (in St. Mary's Churchyard).

two thousand pounds, including the beautiful statuary ;
but such a cross as Cricklade might be erected for about
a hundred or a hundred and twenty pounds, even at the
present advanced price of labour. This cross formerly stood
on four substantial stone-steps, the top one was bevelled

off very neatly into an octagonal base, and it was sur-
mounted by eight very elegant quatrefoils; these, again,
were splayed off till they assumed the proportions of the
shaft. The shaft is crowned with a very fine tabernacle,
having four angels for supporters; but the figures in the
niches of the tabernacle have unfortunately disappeared.
This cross has been engraved in Britton's "Antiquities of
England;" there is also an excellent little copper-plate
by Roberts, from a drawing by John Hughes, for the
"Antiquarian Itinerary," date 1817, and published by
Clarke, of New Bond Street. There are also several other
engravings of it before me, but they are not dated, though
apparently of equal, or perhaps rather greater, age.

This cross has, as before stated, been removed into
St. Sampson's churchyard, where it has been carefully
re-erected. At the further end of the town is another and
very similar structure, which stands in St. Mary's church-
yard, and forms a most beautiful outline against the
chancel of the old parish church. The figures are com-
plete in this, and the shaft is very similar, but the base
is not so graceful as that of the other cross. On the side
facing the road are two figures in one canopy, which seem
to be those of a knight and lady, possibly the builders of
the cross.

There is a curious tradition regarding the origin of the
name of Cricklade. Some persons, Camden tells us, are of
opinion that it is a corruption of Grekelade, from the
circumstance that "Greek philosophers" founded a uni-
versity there, which was afterwards removed to Oxford.
Undoubtedly, according to the monks, such a university
did at one time exist; but to derive the name from this is

rather a forced example of etymology; and the circumstance that the university was said to be removed to Oxford long before there was any university at all, clearly militates against the credibility of the narrative.

The cross at Pershore, in Worcestershire, resembles those at Cricklade in proportions, though it is even simpler and plainer in design ; it stands on two steps, and on the top one is a solid base "broached." The tabernacle of this cross has been destroyed. Pershore is said to derive its name from the number of pear-trees that grew in its vicinity; it is delightfully situated on the Avon. The cross is a preaching-cross, and was connected with the monastery, of which some picturesque remains are yet standing. There were other crosses here, but they have been destroyed. Near the gateway, which at present remains, stood the small chapel of St. Edburga, to whom the abbey was dedicated : she was a daughter of Edward the elder. Her father once placed before her some valuable jewels and clothes of the latest fashion, and also, a little way apart, a copy of the New Testament, desiring her to choose between them, when she at once rejected the garments and jewels for the New Testament,; after which her father sent her to Winchester, where she died, and where her bones were preserved as a valuable relic for many ages. There were two crosses at Pershore to her memory.

XII:

OLBEACH Cross was pulled down at the latter end of the seventeenth century, but a very fair print of it still exists, taken from a drawing by Dr. Stukeley in 1722. A legend on the engraving reads—"Ob amorem erga solum natale temporum ignorantia direptam restituit. Wo. Stukeley." The cross is so curious, and the print itself is so scarce, that it was thought well to copy it for the present work, only altering the lines of perspective, and correcting some very obvious errors that show for themselves in the details. The cross was pentagonal, after the manner of Leighton-Buzzard, but it had no central column, the angle buttresses acting instead; this gives the structure great lightness, and increases its capacity as a shelter. There were five angle-pinnacles to support the lateral thrusts, and the edifice was groined inside.

The woodcut here introduced probably gives a very fair idea of this beautiful and interesting structure, which is unique, and deeply we must share Dr. Stukeley's regret at its destruction.

Holbeach is an old-fashioned town in Lincolnshire, and is about forty miles south-east of Lincoln; it was formerly

called Oldbeche, from the town having been built near an

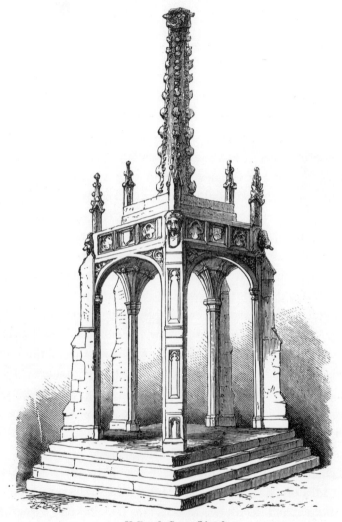

Holbeach Cross, Lincoln.

old beach left by the recession of the sea. It contains a
fine old church, and there is a free grammar school,

founded by Edward III.; the lands, however, which were granted for its support seem to be unaccountably lost. Holbeach was the birthplace of the learned Dr. Stukeley, the antiquary, author of *Itinerarium Curiosum.*

There are no remains of the crosses that formerly adorned Lincoln city; indeed, this part of England is not by any means so rich in crosses as in other ecclesiastical remains. Boston and Grantham crosses seem to be more remarkable for the height of their steps, rather than for any architectural features of merit. The latter is a high octagonal shaft on a flight of steps that diminish rather gracefully; and the shaft also diminishes until it reaches its proper thickness.

At Lincoln, however, is a fine old wayside conduit, which is fairly entitled to rank among the crosses of England. It is situated near St. Mary's de Wigford Church, said to be one of the few Saxon remains in England. The cross is rectangular in plan, and has angle-buttresses; the panelling is of the fourteenth century—towards the latter part of that period—and is very graceful. It is the finest example of a well-cross left in England. The water which supplies the little basin is brought through leaded pipes from a distance of a mile; these pipes are more modern than the structure, having been laid down during the reign of Queen Elizabeth.

There is no doubt that, from whatever cause, the crosses in this part of England, and as far west as Shropshire, were those that suffered most. Two ludicrously helpless-looking statuettes of Crispin and Crispianus over a shoe-makers' resort in Shrewsbury, as if deprecating the

Puritan zeal that was destroying so many of their fellows, say—

> " We are but images of stonne,
> Do us no harm—we can do nonne."

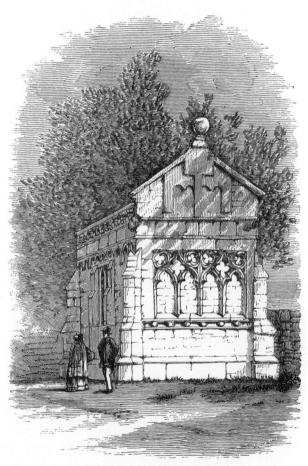

Conduit near St. Mary's, Lincoln.

St. Mary's Cross is situated in High Street, Lincoln, which is one of the finest old English streets left; the vast

cathedral, from its height, seems to overshadow the city
as we walk up towards it, and many are the remains of
antiquity on each side. The actual high-cross of Lincoln,
as it is properly called, was destroyed long ago. Remi-
gius built a cross here, which has perished; he founded
the see of Lincoln, having removed it from Dorsetshire.
Hugh de Grenoble also built one or two crosses in
Lincoln which have likewise perished; he succeeded
Remigius, and after him Hugh de Wells and Bishop
Wells built crosses which have shared no better fate
than their predecessors.

Langley is about ten miles from Norwich; at one
time it contained a monastery. The singular old cross
is probably of the fifteenth century, though it may be
a little earlier. On the panel at the north side there
seems to be the figure of an angel unfolding a scroll,
though it is not very certain what it is. On the east
and west are two grotesque animals; that on the west
has wings, and that on the east side seems to be a
sort of parody upon a lion. The canopied statues are
curious, and unlike any others we can call to mind;
three of them are holding shields, and the fourth, on the
east side, has a singular model of a lamb. The splayed
base is very curious, and there are no traces of its having
been broached.

Langley Cross is situated in the hundred of Lodden,
which is about nine miles and a half distant from Nor-
wich, in a south-easterly direction. The river Yare,
on which Norwich is situated, is close by, and the
country is very beautiful. Langley Park has long been
the seat of the Proctor family; the grounds cover eight

hundred acres. Langley Abbey, to the good offices of
which we owe the cross, was founded for the Premonstra-
tensian canons, in the year 1198, and was dedicated to

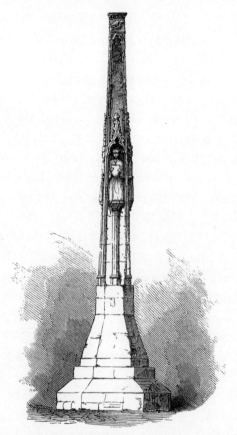

Langley Cross.

the Virgin Mary. There were at one time in all fifteen
religious houses here, and their united revenues, at the
dissolution of monasteries in the reign of Henry VIII.,
were £229.

The Monastery of Norwich, some ten miles distant, is remarkable for having been the scene of many conflicts between the inhabitants of the city and the clergy. There

North Petherton Cross.

were several very beautiful crosses in its jurisdiction, erected at the expense of the monks; but they were rudely destroyed by the soldiers of Cromwell, who filled the cathedral, as Bishop Hall pathetically says, "drink-

ing and tobaccoing as freely as if it had turned ale-
house."

North Petherton Cross is situated in a pleasant part of
Somersetshire, and is a good example of Perpendicular
work, though without the tabernacle. The square sides
give it rather the appearance of an obelisk.

Base of a Cross in Bebbington Churchyard, Cheshire.

Bebbington Churchyard, near Chester, contains a fine
old base (circ. 1500); and in the grounds of Delamere
Abbey is the head of a cross apparently about A.D. 1350,
—probably one of the sanctuary crosses before spoken of,
where travellers halted on their road through the dan-
gerous Royal forest.

In concluding this brief history of the crosses of England it is of course obvious that a number of unimportant examples must have been omitted, and perhaps it may be thought that undue prominence has been given to others. The fact must be borne in mind, that the materials for writing such a history are slight, but wherever any records

Head of Cross, Delamere, Cheshire.

have been obtainable they have been made use of; probably, also, the story of one cross would be that of a hundred others. Fosbrooke, in his curious book of antiquities, has given a methodical list of the different forms. There are first, he says, the *preaching-crosses*, or crosses from which friars used to preach. Then there are the *market-crosses*, of which so much has been said, and which, in fact, constitute the principal remains now in England.

He also enumerates *weeping-crosses*, or penitential shrines; and then *street-crosses*, which perhaps are included in market and preaching crosses; *crosses* of *memorial*, built either as sepulchral monuments or in memory of some notable action; *landmark-crosses*, which differ materially from every other kind mentioned, and were, and are yet, the most accurate and reliable data in parish boundaries. The abbey-lands round Chester seem to have been marked out with great regularity in this way, though indeed many, or nearly all of them, were destroyed very long ago. He also mentions *crosses* of *small stones*, where a person has been killed; *crosses* in the *highway*—these were, of course, of every kind, either like the Eleanor crosses, or boundary-crosses, or, indeed, preaching-crosses; *crosses* at the *entrance* of *churches*, to inspire devotion—and, unhappily, these beautiful remains seem to have suffered more severely from Puritan zeal than any other. Finally, he enumerates *crosses* of *attestation* of *peace*, erected by some monarch who was defeated or otherwise; these are mostly of a very ancient type. This list of Fosbrooke's is very curious and interesting, it may be a little fanciful; but he was a keen observer, and had the advantage of seeing many crosses now no more. It also affords indirect evidence of the number of these structures which must at one time have adorned the land.

Doubtless our wayside monuments of crosses sink into insignificance when compared with those of the old Appian Way leading into Rome; perhaps, indeed, nothing can give us even the slightest idea of this extraordinary scene, for the history of the world contains no parallel. The monuments erected along the wayside dwarf our

Eleanor crosses as far as cost was concerned. The Appian Way was, in fact, one vast Westminster Abbey, a quarter of a mile deep in monuments, and sixteen miles in length, broken here and there by some luxurious, magnificent villa, such as that of the Quintilii, whose grand retreat proved too great a temptation to Commodus, and caused him to have them destroyed, in order that this infamous usurper might inhabit their halls. The present Pope has earned the gratitude of all students of antiquity by the excellent means he has taken to have all monuments restored, and the *débris* removed as far as possible; though even with this advantage we shall never again have more than a very slight idea of the Appian Way in its grandeur, for invaders of the Eternal City, such as Alaric, Totila, and Belisarius, laid her suburbs waste, breaking down the carved work of these wayside monuments, and using up the materials for any possible purpose they might require them; indeed, considering the extent of the remains after such visitations, the wonder is that any wayside monument is left at all. But not only was the Appian Way adorned with roadside monuments, the Flaminian and Latin ways were also lined with grand tombs; Juvenal says :—

" Quorum Flaminiâ tegitur cinis atque Latin."

There are many Christian tombs along these roads erected at a later period, and bearing the symbols of the Christian creed, which, indeed, might pass for classic monumental roadside crosses.

Greek artists were employed on these beautiful memo-

rials, or, at any rate, on the best of them, and we should have to go back to the days of Alaric to know what they were like. The destruction of our own roadside crosses has been almost as complete, and perhaps as many priceless designs have also been lost among them.

On the way in which roadside monuments, as well as other ancient buildings, were made to suit the character of the surrounding scenery, there is an interesting example in that delightful book, Laborde's "Sinai," and I venture to quote some remarks I once made on a former occasion on this subject :—

"Perhaps Idumea is among the least promising sites for an architect to attempt to mould into beauty, but it illustrates the point under consideration well. This was the ancient city of Edom, and was situated in the very middle of the rocky fastnesses of Arabia Petræa. It was approached by only one long road of about four miles, which has no parallel in history. The hills rise up abruptly on each side to some four hundred feet in height; and they often appear to close over head, owing to projections in the rocks at vast heights above. In places it is of course quite dark, and only a gleam of light ahead directs the traveller. Yet this astonishing highway was once covered with geometrical pavement, and its sides were lined, wherever an opening rendered it possible, with monuments and memorials corresponding with English roadside crosses in aims and uses. Ages before the Roman occupation, Edom was look upon with mysterious awe: 'Who will lead me into the strong city? who will bring me into Edom?'"

The amazing scene that presented itself at the end of

this street is familiar to us from reading the pages of Laborde. Rocks cut and scarped out into temples, tombs, and dwellings are scattered about in great profusion ; but all harmonize with the landscape, if so it can be called, for the tunnel-like road ends in a kind of vast amphitheatre, formerly the great city. Just before it terminates is a rock temple, beautifully illustrated in Laborde's book, and which appears to be of the time of Vespasian or Titus, and shows how well old architects could improve even a gleam of light, so long as it was a recognisedly permanent feature, and not to be disturbed by passing events; but it cannot be given better than in the words of Captains Irby and Mangles, who are among the very few Europeans that ever saw these regions :—

" When the rocks are at the highest, a beam of stronger light breaks in at the close of the dark perspective, and opens to view—half seen at first through the narrow opening—columns, statues, and cornices, of a light and finished taste, as if fresh from the chisel, without the tints or the weather-stains of age, and executed in a stone of pale rose colour, which was warmed, at the moment we came in sight of them, with the rays of the morning sun. The dark green of the shrubs that grow in this perpetual shade, and the sombre appearance of the passage whence we were about to issue, formed a fine contrast with the glowing colours of the edifice. We know not with what to compare this scene ; perhaps there is nothing in the world that resembles it. Only a portion of a very extensive architectural elevation is seen at first; but it has been so contrived that a statue with expanded wings, perhaps of Victory, just fills the centre of the aperture

in front, which, being closed below by the sides of the
rocks folding over each other, gives to the figure the
appearance of being suspended in the air at a great
height, the ruggedness of the cliffs below setting off the
sculpture to the highest advantage. The rest of the
vast *façade* opened gradually at every step as we ad-
vanced."

With this sublime description of a wayside monument,
erroneously called by the Arabs Pharaoh's tomb, we may
bring our notices of the stone crosses of England to a
close. Of course we have no such grand opportunities
to misuse in England; but one thing is certain, that until
recently architects rarely considered their surroundings,
but simply drew their plans on paper, in four square
walls, disdaining everything in the shape of picturesque
adaptability.

In regarding the old crosses (which are, perhaps, not at
all times the most beautiful architecture of their age,
always excepting the Eleanor crosses, and remembering
that we know very little of the others), we naturally fall
into this train of reflection; those we have noticed seem,
as a general rule, to be designed to fit their situation,
and form a pleasant object in the landscape. On this
subject, as we have before remarked, an architect who
has a building to erect should carefully sketch the site
and the landscape, in order to see how the building will
look from the various windings of the highway; where
it should stand clear of a hillock or a group of elms;
were chimneys would tell, or where bow windows; and
finally look upon it as a picture set in a frame. And
he is sadly wanting in ingenuity who is not able with

ease to adapt this to the requirements of his work; indeed, such a general survey would be of the greatest possible assistance in the item of the arrangement of the rooms of a building ; say, for example, a dwelling-house. It would at once relieve of much consideration as to where rooms of entertainment should be, where the domestic offices or stables should stand, and how far the building should be from the road, with many other problems that he is only working at in the dark in his office.

THE END.

INDEX